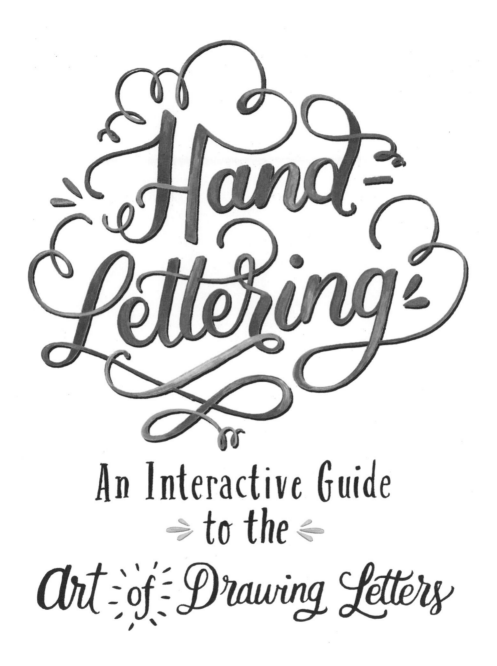

An Interactive Guide
⇒ to the ⇐
Art ⋅of⋅ Drawing Letters

WRITTEN AND ILLUSTRATED BY MEGAN WELLS

 Peter Pauper Press, Inc.
WHITE PLAINS, NEW YORK

*To my husband Brent;
together we are two old shoes.*

Illustrations and text copyright © 2016 Megan Wells

Designed by Heather Zschock

Copyright © 2016
Peter Pauper Press, Inc.
202 Mamaroneck Avenue
White Plains, NY 10601 USA

Published in the United Kingdom and Europe by
Peter Pauper Press, Inc., c/o White Pebble International
Unit 2, Plot 11 Terminus Road
Chichester, West Sussex PO19 8TX, UK

ISBN 978-1-4413-2201-2

Printed in China
7 6 5 4 3

www.peterpauper.com

Hand-Lettering

An Interactive Guide
to the
Art of Drawing Letters

Contents

Intro

I've been drawing since I was an itty-bitty child. I have vivid memories of my sister and I sitting together at our designated art table, creating masterpieces: cards for our grandparents, decor for the fridge, and as we got older, signs for friends' lockers and covers for notebooks. Horses, buildings, Disney characters. I was always drawing.

In college, I discovered my love for mixed media, getting my hands dirty with paints and dirt and coffee grounds. And then oil paints, the colors blending seamlessly. Pastels and their chalky dust all over my hands, and oftentimes, face. I explored installation, becoming a display coordinator at Anthropologie, a store known for its gorgeous, hand-crafted decor.

And then, after six years of teaching high school art, and taking the great, big, scary leap into life as a full-time freelance artist, I discovered lettering.

I'd been drawn to art incorporating letterforms for a long time. I loved to sneak words into my work here and there. But they were always in the background, printed in a font I'd emulated.

But in the summer of 2012, as I sat in my new, tiny studio, no paycheck on the horizon, yet with my husband's full confidence and encouraging support, I started drawing letters.

My first lettering projects were laughable, but I kept at it. I practiced and practiced and practiced some more. I began addressing envelopes for brides, specifying that I was not a calligraphy artist, I was a hand-letterer. Addressing envelopes was painfully boring for me after a while, but it was paying the bills. And it was giving me constant, repetitive practice. Soon the envelopes led to

lettering for invitations and day-of wedding signage. I began lettering quotes and Bible verses, adding floral elements and selling them as prints. This led to that, and then that led to something else as I explored who I was going to be as an artist…but the one constant was that I was always lettering.

I'm writing this book because I want to share how I'VE learned hand-lettering. What you'll find inside are techniques and perspectives that work for me. And the basic principle I've followed throughout is that I have to **approach lettering the same way I approach drawing everything else.**

So inside this book, on almost every page, remember to draw. I won't be showing you how to arrange typefaces or fonts (typography) and I won't be showing you how to write beautiful letters with a brush or pen (calligraphy). Learning about those topics will benefit your lettering greatly, and I encourage you to do so. But those aren't the skills or techniques we will focus on.

This book is about the physical making, the pencil-smudged sides of your hands, eraser scraps, and spilled ink. It's not a book about digitizing in Illustrator or the fine points of typography, but instead a unique perspective approaching the art of hand-lettering from the eyes of a quirky fine artist.

Thank you for giving my approach a try. Whether you are a seasoned letterer, or a total beginner to the subject, I hope this book encourages you to practice and practice and practice some more.

And of course, I hope you learn something, too.

Megan

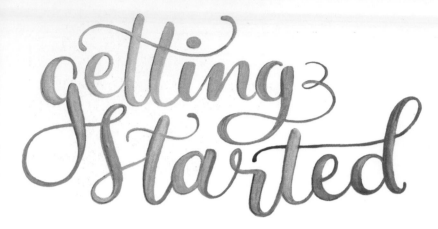

DRAW, DON'T WRITE

One way to think of the difference between calligraphy and lettering is that calligraphy is based on penmanship, or writing letters, while lettering is based on draftsmanship, or drawing them. **So to improve your lettering skills, essentially you are looking to improve your drawing skills.**

As you work through this book, you'll be reminded again and again to DRAW. Sketch, doodle, and paint to your heart's delight, but please, whatever you do, don't write.

Change your viewpoint and see letterforms in a new way. Focus on the shapes, the curves, and the negative space. Just as you would sketch a flower from your imagination, sketch the shape of each letter.

TRACING PAPER IS YOUR FRIEND

There are practice pages throughout this book, following most sections. Some are blank pages with prompts to spur your creativity, while others provide lightly drawn letters and characters for you to trace. "But tracing is cheating!" you might be tempted to say. So let me clarify:

The more you do something, over and over, the more trained your eye and hand will be. Tracing paper is a cheap and simple way to practice drawing letters. Tracing over the alphabets provided in this book isn't cheating.

I encourage you to use these tracing pages as a starting point or guide before moving on to sketching freehand. And keep a pad of tracing paper handy, as it's an easy way to refine your sketches.

As your technical skills grow, your personal style will begin to evolve. This doesn't always happen quickly, so be patient and allow yourself time to discover your lettering "voice."

I'll often use tracing paper as a tool for discovering new ideas. Here's an example of what I mean:

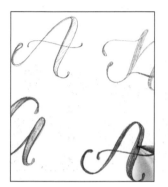

After sketching the letter A a few times, I settled on one that I liked.

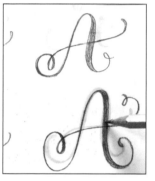

Then, using tracing paper, I lightly traced that A again and again, each time making subtle variations. I used the A I liked as a guide, but made adjustments on each new A.

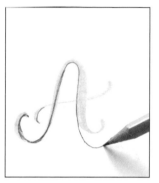

After many attempts, I finally discovered the A I was looking for!

DON'T BE AFRAID TO PLAY!

Lettering can seem super technical sometimes, which stifles my creativity. When this happens, I try to force myself to loosen up and remember that I'm not performing brain surgery, I'm making art!

You will draw ugly letters. You will draw wonky curves. For every ten letters you draw, you may only remotely like one. But instead of giving up, I encourage you to mix it up and keep drawing.

Draw big instead of small.
Sketch with a colored pencil instead of graphite.
Change the radio station.
Loosen up.
And let yourself play!

Supplies

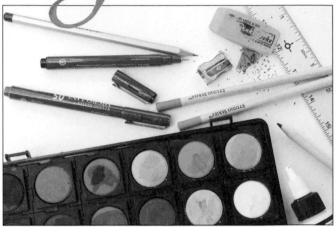

Getting started with hand-lettering is easy (and cheap!). All you need are your basic drawing supplies: pencils, an eraser, paper, tracing paper, and a straightedge (such as a ruler). And none of these need to be fancy. Most of my sketches are done with a mechanical pencil in my sketchbook or on basic copy paper. You can invest in lined or gridded paper, though I prefer to draw my own guides using a straightedge.

Of course, as you get more practice drawing letters, you'll want to explore different tools to work with. My favorite pen might end up being one you avoid. The key is to experiment and find what works for you!

In this book, we'll also take a quick peek at painting letters, using watercolors and acrylic. Don't let this send you into a panic if you've never painted! Just give it a shot and keep in mind that painting is simply another form of mark making (making a mark, with any tool or supply, on any surface). You are drawing…but with paint. And just like lettering, the more you practice, the easier it will become.

The first half of this book will focus on drawing, so starting with just the basics is okay! Once you begin adding color in Section 3, gather up some pens, paints (acrylic and watercolor), and colored pencils. I've highlighted some of my personal favorite supplies, but basic budget supplies work just fine!

THE BASICS:

Pencil, paper, eraser, sharpener, straightedge (ruler), tracing paper

MEGAN'S TOOLKIT:

PENCILS: I use **mechanical pencils** on the go (no sharpening!) and **Raffiné Graphite Pencils**.

PENS: Studio Series Micro-Line Pens are my favorite for linework. They are waterproof and come in a variety of nib sizes.

ALCOHOL MARKERS: These are very versatile and come in a ton of colors.

SHARPIE PENS: These are easy and affordable. I take one everywhere I go.

PAINTS: Dr. Ph Martin's Hydrus Fine Art Watercolor is a splurge, but worth it if you love bold, concentrated pigments.

For on the go, I love the **Studio Series Dry Gouache** paint set. The colors are more opaque than your typical tray of watercolors, which I like.

ACRYLICS: I have about every kind of acrylic paint there is, from value craft paint to more expensive brands. My advice is to start cheap and find what works for you! Some of my favorite brands are **Golden** and **Blick**.

COLORED PENCILS: Studio Series and **Prismacolor** are my two favorites!

LIGHTBOX: A lightbox is a great tool for tracing on non-translucent papers. Instead of redrawing a final rendering by hand on your paper, a lightbox provides a way to easily redraw your lettering accurately on many kinds of paper. I have an **Artograph LightPad**, which I love for its affordability and brightness.

BRISTOL BOARD: Most of my final lettering pieces are done on **Strathmore Bristol Board**. I've found the vellum surface great for painting as long as I don't use too much water. It has a smooth, heavyweight consistency which is wonderful for colored pencils as well.

Lettering Basics

Before you embark on your lettering adventures, get yourself in a playful, creative mindset by adding color to the opposite page!

In the lessons ahead, you'll learn terminology, tips, tricks, and a lot about the craft side of lettering. Follow along and practice, but amid all the rules and guidelines, don't lose sight of your mischievous artistic vision. If you want to approach the process of drawing a letter differently from how it's outlined, go ahead. And if you have an idea for modifying a letterform, try it out! Who knows what you'll come up with?

Lettering Basics

It's important to get to know a few basic types of letters. I'll highlight the three I consider to be the foundation for all other letters. Based on the three types of letters on the opposite page, there are infinite ways to draw the 26 letters in the alphabet (52 if you think upper and lowercase)!

Letters also come with a lot of terminology. I will admit, I could care less about all these terms. It's more fun to say "just make that curvy part fatter with a rounded point on the end." But for those of you with a little more of your left brain intact, I'll highlight a few important ones.

Mimicking calligraphy style, **upstrokes** are usually thinner, as less pressure is used when writing. **Downstrokes** are usually thicker, as more pressure is used.

SERIFS are small strokes added to the ends of the main strokes of a letter. Serif style letters are like letters wearing clothes!

A **SANS SERIF** letter is a naked letter! Sans means "without" in French, so essentially this is a letter without a serif.

SCRIPT lettering styles resemble cursive handwriting or calligraphy. This is my favorite style of lettering to draw!

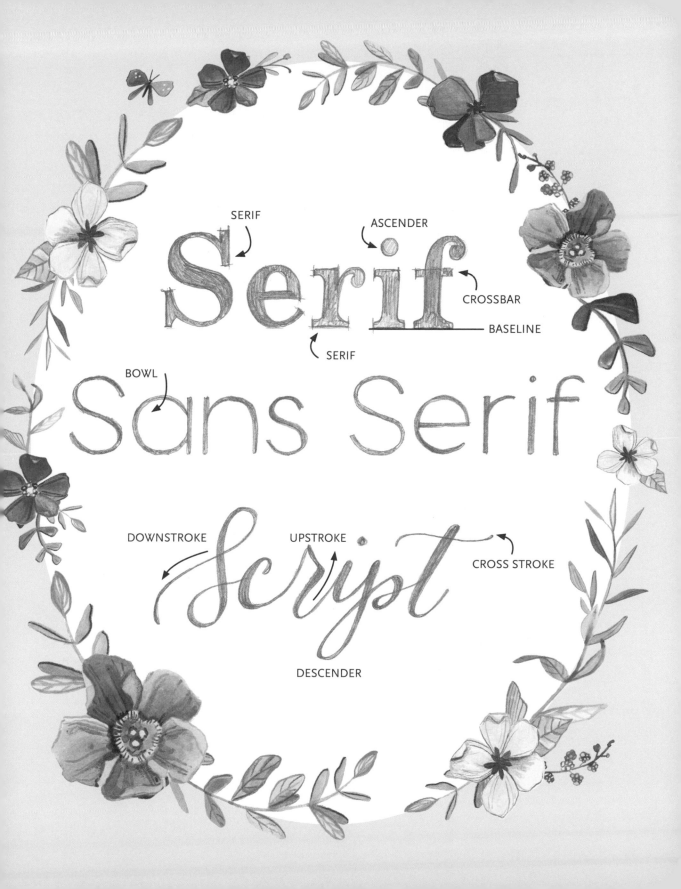

SERIF

ASCENDER

CROSSBAR

BASELINE

Serif

SERIF

BOWL

Sans Serif

DOWNSTROKE UPSTROKE

CROSS STROKE

Script

DESCENDER

Get your creative juices flowing by coloring the letters above,
then learn to create your own letters!

FIVE LETTERING STYLES

There are countless styles of letters to be drawn. A new way to draw a letter can always be discovered, which is what makes hand-lettering so creatively appealing. By building off of a few basic lettering styles, you can find your own unique approach. In this section, we'll look at just five of those styles to practice and then make your own.

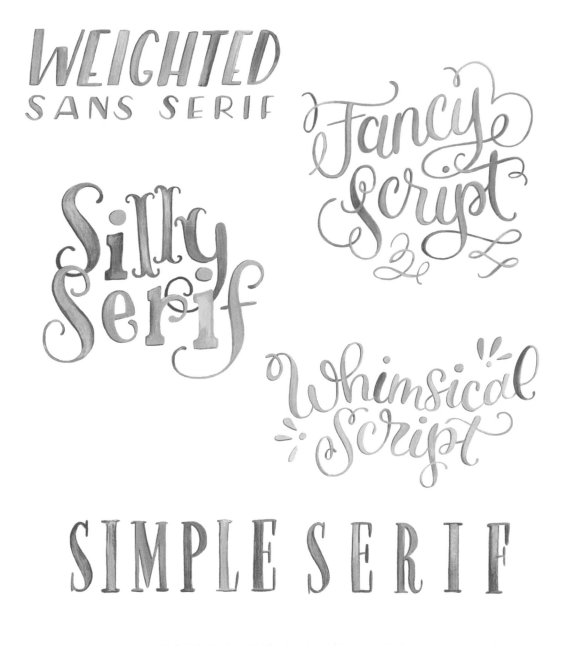

WEIGHTED
SANS SERIF

This weighted sans serif style is a perfect place to start practicing your lettering skills. This style builds upon a basic printed letterform, beefed up on the down-strokes. Remember, sans means "without," so this style is simple and clean.

Aa Bb Cc Dd Ee
Ff Gg Hh Ii Jj Kk
Ll Mm Nn Oo Pp
Qq Rr Ss Tt Uu
Vv Ww Xx Yy Zz

HOW TO DRAW A WEIGHTED SANS SERIF LETTER:

1. Draw the letter's skeleton.

2. Add weight to the downstroke.

3. Shade in and freshen up by erasing stray pencil marks and refining edges.

There are many easy ways to vary this style.

rounded

Curve your letters for a less formal look.

curved

Play with ascenders and descenders.

whimsical crossbar

Add an interesting crossbar.

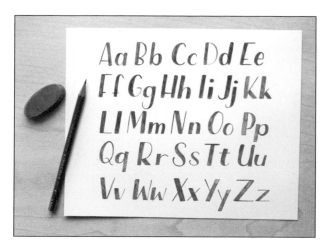

Trace over the letters, then practice drawing them on your own.

Aa Bb Cc Dd Ee

Ff Gg Hh Ii Jj Kk

Ll Mm Nn Oo Pp

Qq Rr Ss Tt Uu

Vv Ww Xx Yy Zz

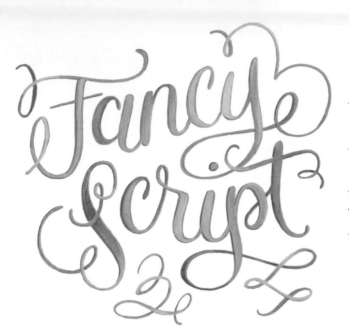

This lettering style can be as formal or informal as you like. Fancy Script plays off the basic calligraphy principle of adding pressure to the downstrokes, increasing the weight (i.e., thickness) of the stroke. The loops and curves add elegance and a touch of charm.

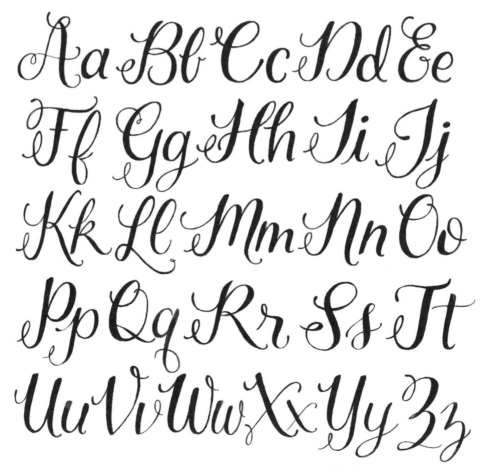

HOW TO DRAW A FANCY SCRIPT LETTER:

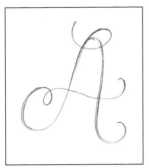 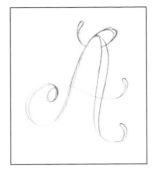 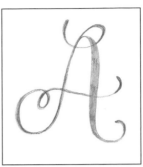

1. Using a pencil, lightly sketch the skeleton of the letter.

2. Add weight to the downstrokes. For this style, try to keep the weight uniform on each letter.

3. Leave the upstrokes and curves thin, then shade in and freshen up!

tips and tricks

- Sketch your downstrokes wider for a less formal feel or thinner for a look that's more elegant.

- Add some more loops for an even fancier look.

- Loosen up! Remember: You are drawing, not writing. It's easier to draw beautiful, sweeping curves if you are relaxed and loose. Shake out the stiffness in your fingers, hands, and arms, and sketch lightly.

Practice drawing these fancy letters or make the letter fancier!

Make the letters fancier

B B
R B
M S
G P

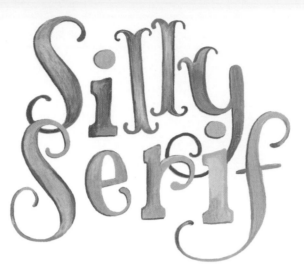

Silly Serif is a printed lettering style with weighted downstrokes, whimsical serifs, and varied angles, which together make this lettering style extra playful! Combining multiple serif styles with quirky curves adds to the silliness.

Aa Bb Cc Dd Ee
Ff Gg Hh Ii Jj Kk
Ll Mm Nn Oo Pp
Qq Rr Ss Tt Uu
Vv Ww Xx Yy Zz

HOW TO DRAW A SILLY SERIF LETTER:

1. Using a pencil, lightly sketch the skeleton of the letter.

2. Add weight to the body of the letter, varying the thickness. Sketch lightly to make erasing easy.

3. Add serifs to the ends of the main strokes.

4. Shade in and freshen up!

VARIATIONS

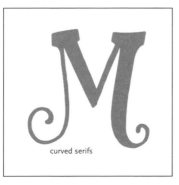

curved serifs

Play with curly, rounded serifs.

equal weight

Add an equal amount of weight to the body of the letter.

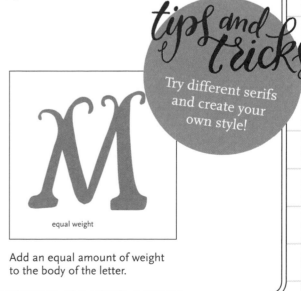

tips and tricks

Try different serifs and create your own style!

Trace over the letters, then practice drawing them on your own.

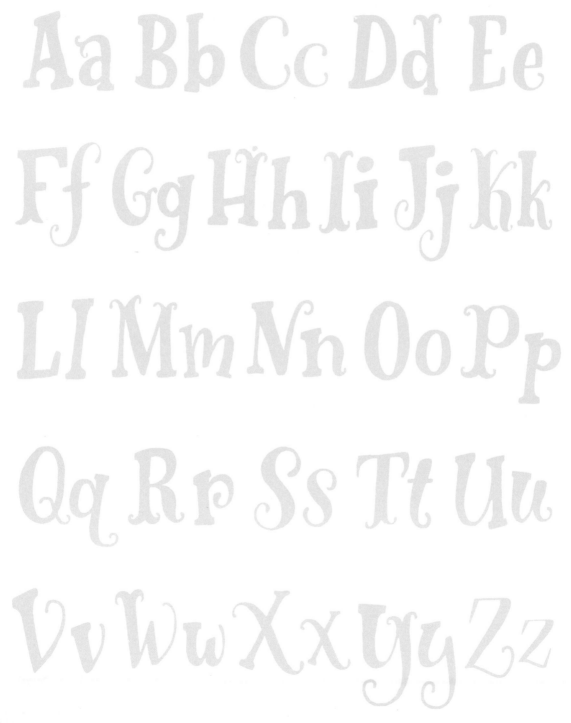

This style of lettering is my personal favorite. Whimsical script is playful and loose, and has unlimited variations! Combining both cursive and printed letter-forms adds unpredictability to this fanciful style.

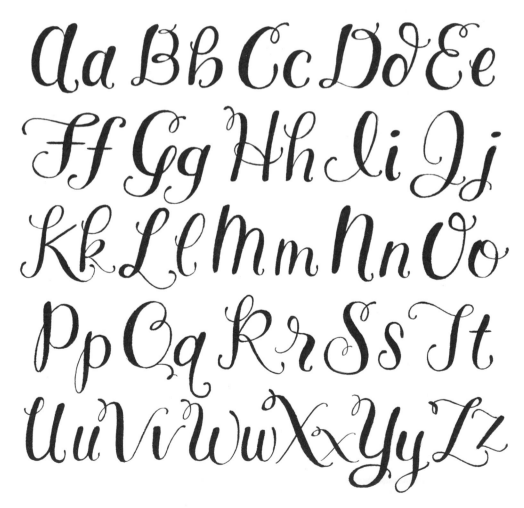

HOW TO DRAW A WHIMSICAL SCRIPT LETTER:

1. Using a pencil, lightly sketch the skeleton of the letter.

2. Add weight to the downstrokes. Try varying the width of the letter slightly for even more whimsy.

3. Leave the upstrokes and curves thin, adding rounded ends to the thin curly flourishes, then shade in and freshen up!

tips and tricks

- Add some extra loops and thin the letters down for a fancier look.

thicker

fixed width

- Try the letters with a fixed width throughout.

fancier (extra loops and thinner)

Trace over the letters, then practice drawing them on your own.

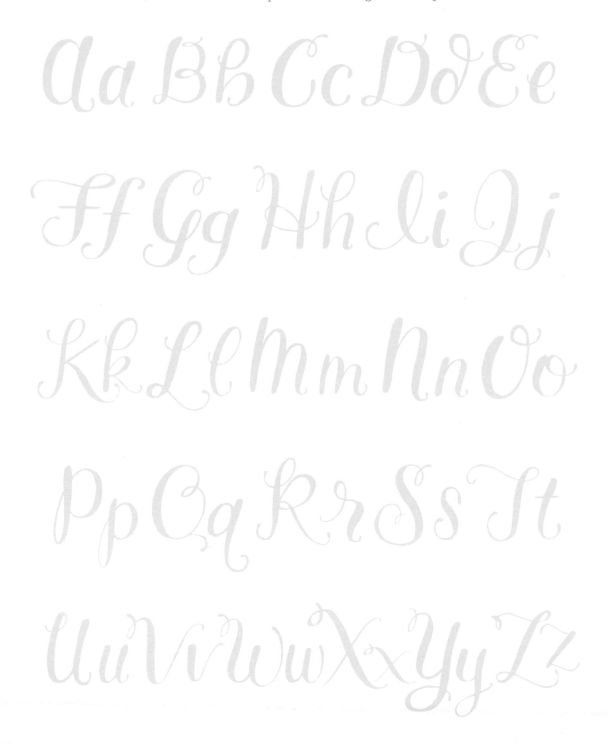

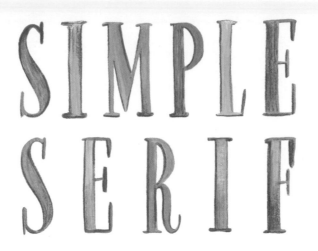

SIMPLE SERIF

Simple Serif is a great style to have in your bag of tricks. It's cleanly drawn, with thin serifs that give it just a touch of charm.

Aa Bb Cc Dd Ee
Ff Gg Hh Ii Jj Kk
Ll Mm Nn Oo Pp
Qq Rr Ss Tt Uu
Vv Ww Xx Yy Zz

HOW TO DRAW A SIMPLE SERIF LETTER:

1. Draw the skeleton of a printed letter.

2. Add even weight to the downstrokes.

3. Add simple vertical or horizontal lines as serifs. Shade in and freshen up!

VARIATIONS:

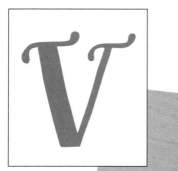

Try curving the serifs for a more whimsical feel.

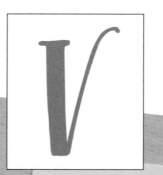

Curve the ends of your upstrokes.

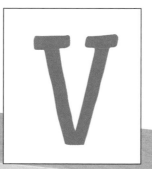

Add even weight to both the letter body and the serifs to create a slab style letter.

Aa Bb Cc Dd Ee
Ff Gg Hh Ii Jj Kk
Ll Mm Nn Oo Pp
Qq Rr Ss Tt Uu

Trace over the letters, then practice drawing them on your own.

Aa Bb Cc Dd Ee

Ff Gg Hh Ii Jj Kk

Ll Mm Nn Oo Pp

Qq Rr Ss Tt Uu

Vv Ww Xx Yy Zz

How Many WAYS CAN YOU Draw THE letter A??

Numbers

Drawing numbers is no different from drawing letters. Think of numbers as simply more shapes to explore!

Numbers mimic the characteristics of letters, so follow the steps I demonstrated for the letters to create your own numbers.

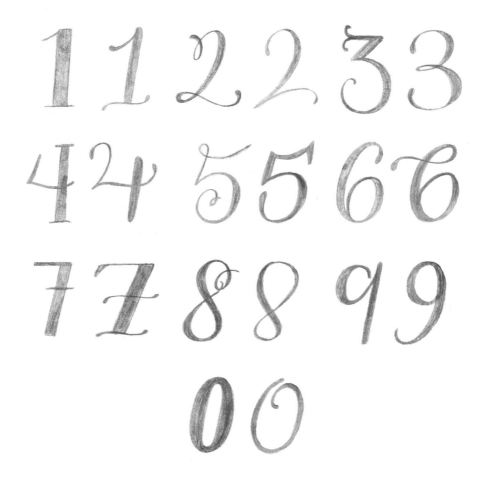

Draw numbers 0–9 in each of the lettering styles you've practiced.

Simple illustrations such as banners, laurels, and calligraphic flourishes can add personality and interest to your lettering. I love adding flourishes to the ends of letters or drawing key words inside a banner or scroll. Practice drawing these extra goodies now, then try incorporating them into your letters!

FLOURISHES are great for making letters feel extra fancy. Draw curving and overlapping lines, and just like a script style letter, thicken the downstrokes!

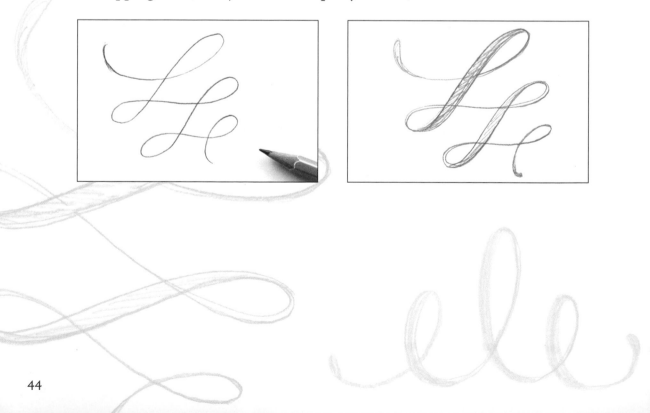

LAURELS are simple to draw as well. Start with a basic curved line, and add some leaves!

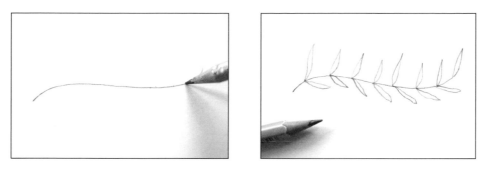

BANNERS are excellent for framing words and an easy way to add a touch of charm to your lettering. For a wavy banner like this, sketch a curvy line for the top of your banner, and a parallel mirror image of the top line for the bottom. Connect with vertical lines and finish off the tails.

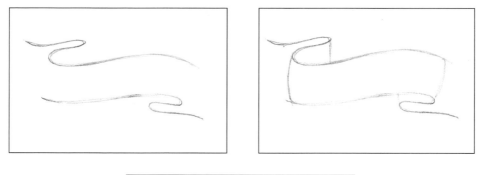

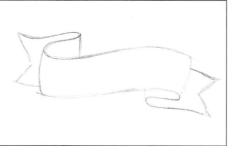

Dots, dashes, curls, and stars—there are so many ways to add character to your lettering! As you improve your lettering skills, your drawing will improve. So remember to sketch and practice as you explore adding decorative elements to your lettering work.

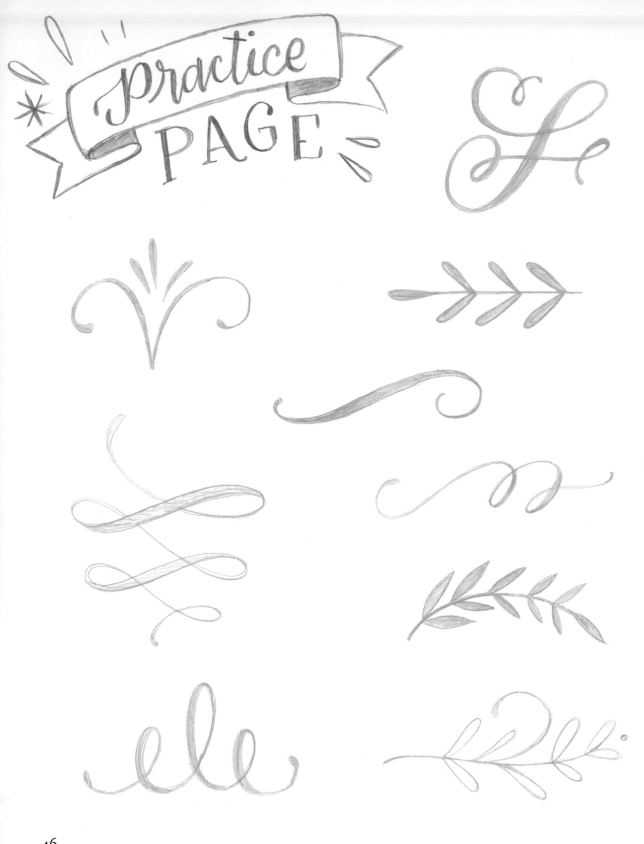

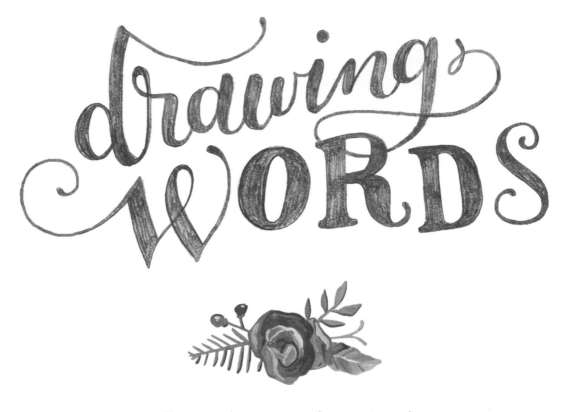

SECTION 2

drawing WORDS

Visually speaking, words are just letters grouped together. The way in which those letters join is in your hands. On a slant, on a curve, connected by flourishes—a word can be drawn in so many different ways!

This section will explore the vast range of creative methods for drawing words, crafting phrases, and putting all the pieces of lettering together.

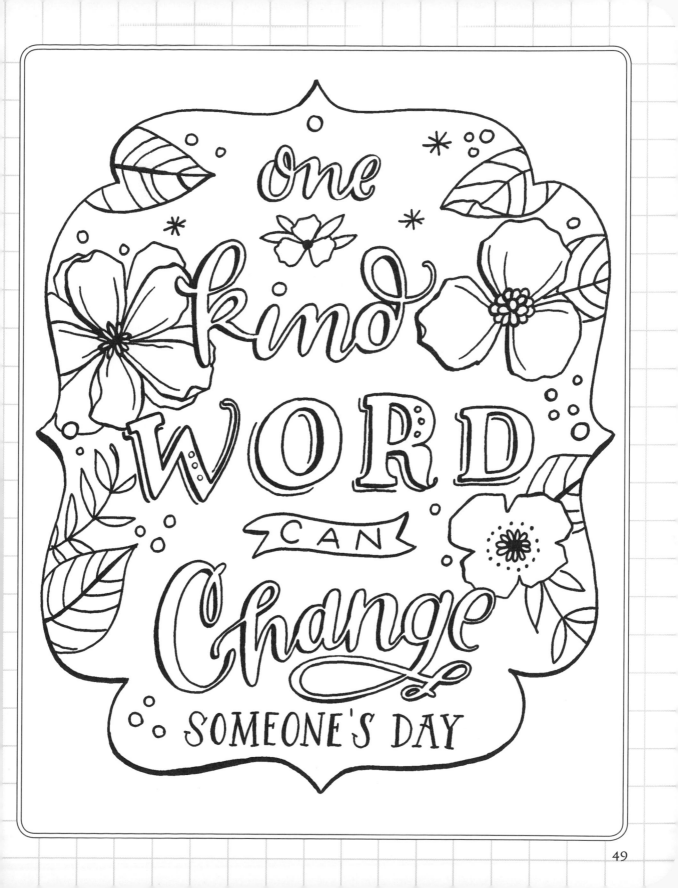

drawing WORDS

BY PUTTING LETTERS TOGETHER

Now that you've learned how to draw letters by themselves, let's put them together and make some words! Connecting letters is a fun way to start practicing! Letters that connect feel most natural with script styles, but there are plenty of ways to get creative connecting printed letters as well.

Letters with crossbars, descenders, or ascenders (see page 15) can make connecting multiple letters together super fun.

The crossbar in a lowercase "t" can connect easily into letters with ascenders.

double crossbar connector

Other letters with crossbars give plenty of opportunities to be creative connecting letters together.

In this example, I used the crossbar of the A and the ascender in the N to connect.

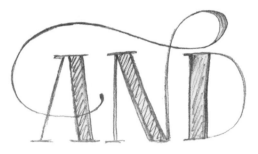

Double letters can also be fun to connect.

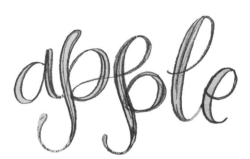

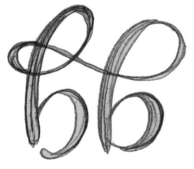

The first or last letter in a word is often a good way to get creative connecting different letters together.

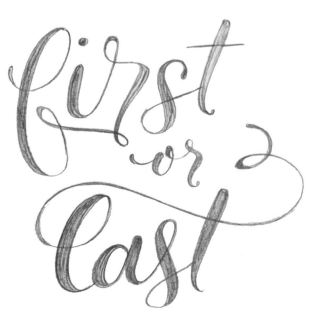

Here are some words to practice with, each containing ascenders, descenders, double letters, and/or crossbars.

PLAYFUL • JOYFUL • MIGHTY • GLITTER

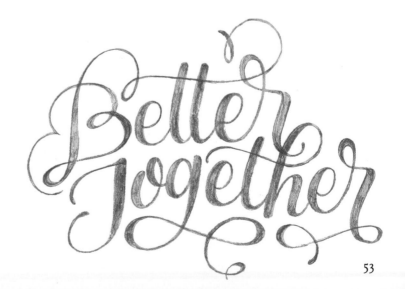

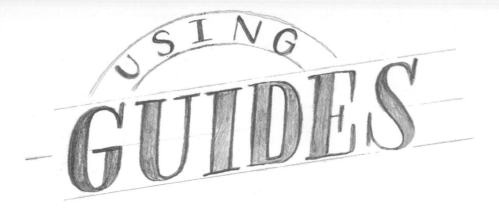

USING GUIDES

Another way to get creative with how you draw words is by creating simple guides, such as slanted lines, curves, or wavy lines. My work tends to be composed more organically, as I typically stick with a loose, scripted lettering style, but occasionally the need for a perfectly arched or slanted word presents itself. When that's the case, I create these very basic guides.

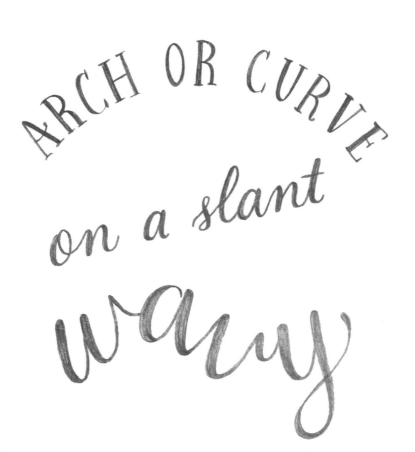

TO SHAPE A WORD OR PHRASE WITH GUIDES:

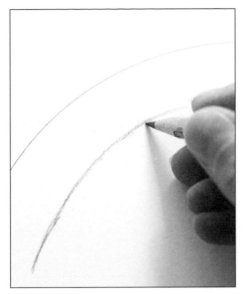

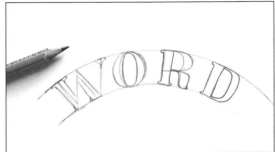

2. Sketch the word, following the guides.

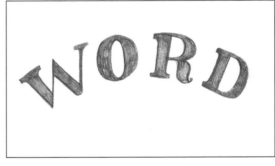

3. Erase guides and voilà!

1. Lightly draw your guides using a straight-edge, compass, or by hand.

- Try keeping the letters vertical.

- Or, try drawing them perpendicular to the curve.

55

Use the guides provided to practice drawing your own words!

Sometimes a blank page can feel intimidating, so I'll often sketch on pre-painted paper to avoid staring at so much white space!

Crafting phrases

Drawing phrases (or words put together) utilizes the same principles discussed when practicing drawing words, or drawing letters. We are now adding one more realm of possibility: the immeasurable ways to combine words.

Phrases are another opportunity to be creative! Think of it this way: If there are infinite ways to draw the letter H, and infinite ways to draw the word "Happy," then there will always be a new way to draw "Happy Birthday to You."

For this exercise, we are going to jump right into drawing this four-word phrase.

When first sitting down to sketch a phrase, I like to grab a few sheets of plain white paper and "free sketch." In the sections to come, I'll be showing you how to create basic guides, how to emphasize catchwords, and essentially how to "map out" your compositions. However, when getting started, I always like to sketch freely and loosely, allowing myself to simply "think on paper." It's a great way to warm up and quickly get some ideas brewing.

So go ahead and just start sketching! I'll often begin by sketching the first letter a few times and then seeing where that leads me. Don't worry about straight lines. Just sketch as if the only tools you have are a pencil and sheets of paper.

As I sketch, I start thinking about the shapes of each letter and how they might connect and interact with each other. After spending a good chunk of time on the first letters in each word, I continue fleshing out my ideas on paper.

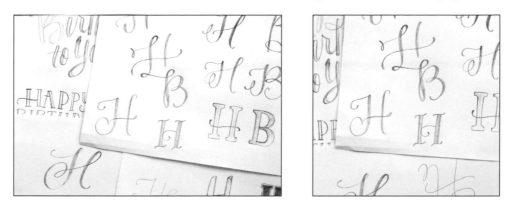

I then look back at my sketches for reference, and begin refining my sketch in the same ways we talked about earlier in reference to words and letters (see pages 8 and 9). I settled on this version, one that combines a whimsical script with a silly serif.

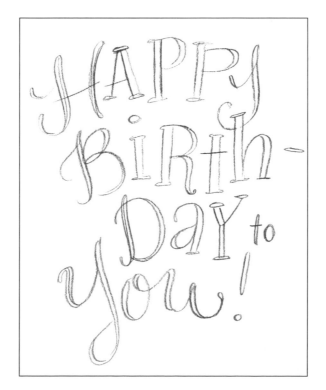

Use these pages for some loose and free sketches of the phrase
Happy Birthday to You!

CREATING BASIC
Composition Guides

For a more structured layout, especially when incorporating a serif or sans serif style, I create a basic composition guide to work from. These guides become a blueprint for where to draw each letter and word.

When working in this fashion, I typically start with quick thumbnail sketches—very small rough sketches outlining the general placement, or composition, of the drawing—before drawing it larger. This way, I can quickly experiment with different guides.

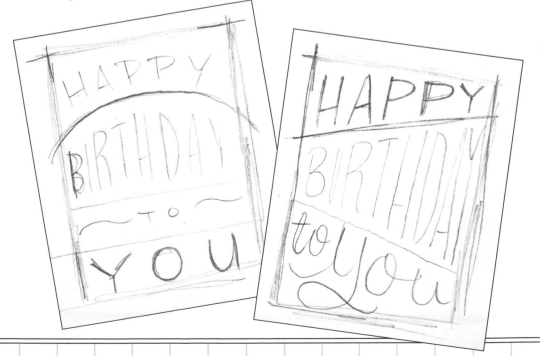

For drawing guidelines, you'll once again need a straightedge and/or compass. Creating a composition guide builds upon those very guides we talked about on pages 54-55. However, now we're incorporating all the letters and words that make up our phrase.

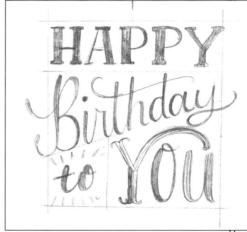

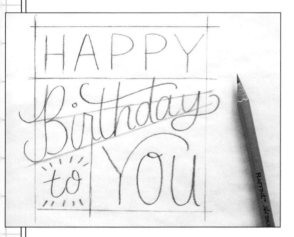

When I begin sketching the letters, I'm most concerned with the size and spacing, not the fine details, so I'll lightly draw just the skeleton of each letter.

I'll then add weight and other details to the letters, such as any serifs or extra embellishments. Keep in mind that this is just a sketch, so it's okay to be a little bit messy!

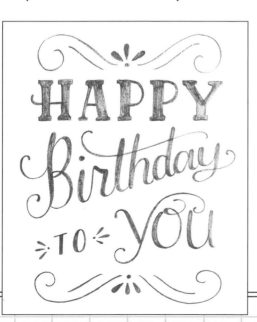

And lastly, after making some mental edits and using either tracing paper or my lightbox, I create a final drawing.

word hierarchy

When crafting phrases, another thing to consider is word hierarchy, or which words have the most importance. I like to group the words I'm working with the same way a sentence would be broken down.

Let's use the phrase "Happy Birthday to You" again. This time, I want "Happy Birthday" to stand out and have the most visual prominence, "You" to be secondary, and our little linking word "to" to have the least importance.

One simple design element can create visual prominence and give a word its top spot in the sentence hierarchy: Contrast.

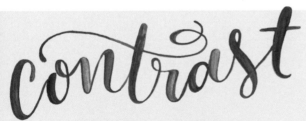

Contrast in art refers to visual opposites, such as light vs. dark, big vs. small, or rough vs. smooth. When drawing letters, words, and phrases, contrast can be used in size, weight, height, style, detail, and other attributes.

BIG small

FAT SKINNY

SANS SERIF

script

CONTRAST THE SIZE OF THE WORDS: In this example, the same style of lettering is used, but the size and thickness variations of the letters lets the most attention fall on "happy birthday."

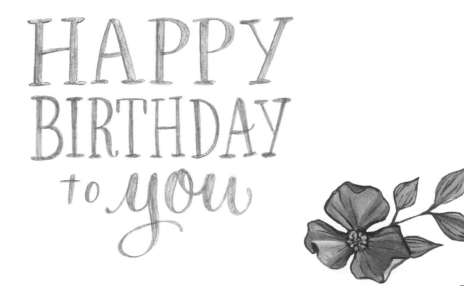

CONTRAST THE STYLE OF LETTERING: In this example, the styles of letters also play a role in creating hierarchy. "Happy Birthday" is drawn in a large, serif style, while the word "to" is done in a smaller, simpler sans serif style. "You" is drawn in a no-frills script style, which helps place it right in the middle of our lettering totem pole.

Practice mixing lettering styles, sizes, and weights to create word hierarchy in the phrase Happy Birthday to You!

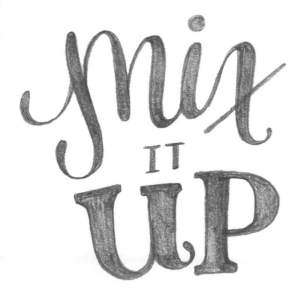

Here's an example that combines the principles we've covered so far.

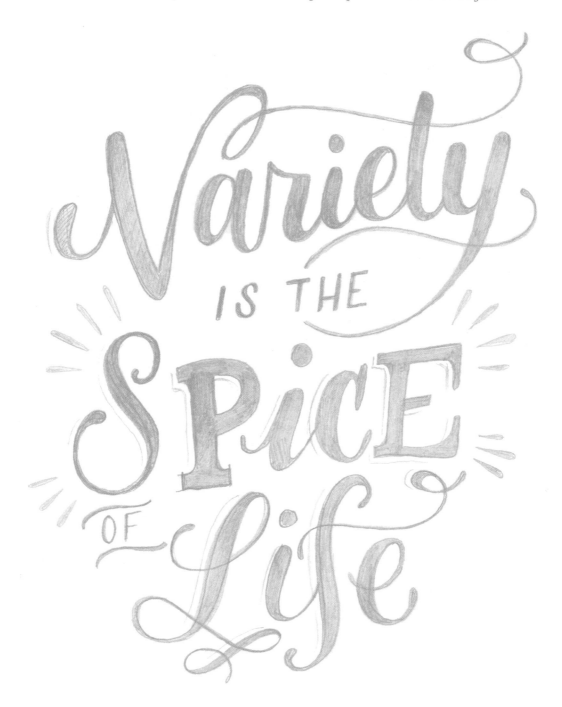

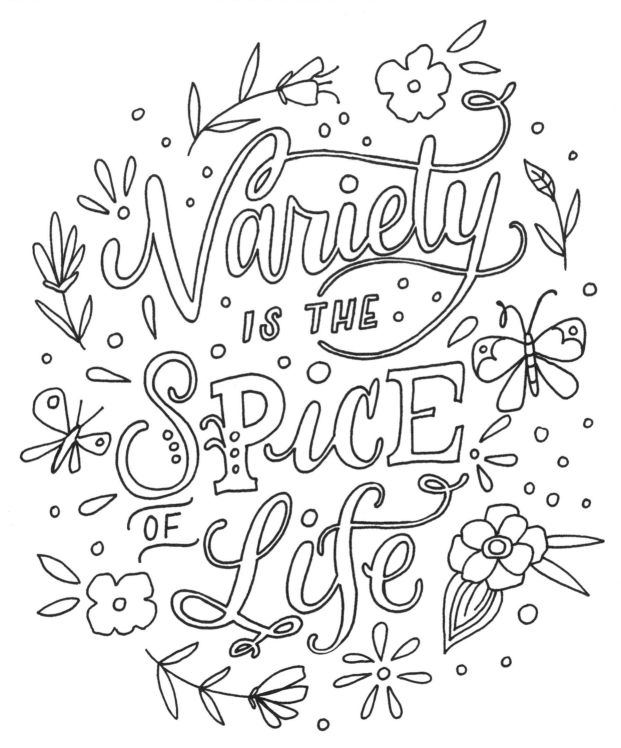

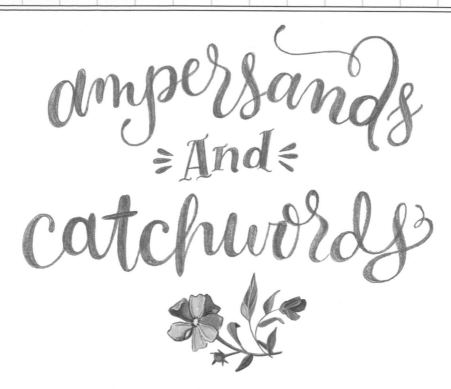

ampersands And catchwords

Sometimes the little things make all the difference. We just touched upon word hierarchy and how to highlight the most important words, but every now and then, it's also fun to showcase those "little" words.

Connecting words (conjunctions such as *and, or, for*), articles (*the, a, an*), and prepositions (*with, at, to*) are sometimes referred to as "catchwords" by lettering artists. Instead of hiding those little "less important" words, you can highlight a catchword in an interesting, more compelling fashion. Dashes, lines, borders, and so much more can help turn those linking words into eye-catching design elements.

An ampersand (*often &*), a symbol that represents the word "and," is often used as a prominent design element in lettering. I love a good ampersand because of its flexibility. It's a super character; you can draw it in an infinite number of ways and people still seem to understand its meaning.

Use the three styles of ampersands on the next page as a starting point for drawing your own!

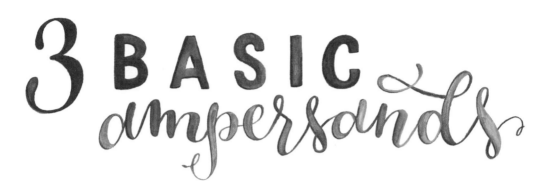

3 BASIC ampersands

 CALLIGRAPHIC

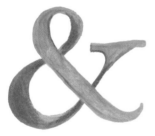 TRADITIONAL

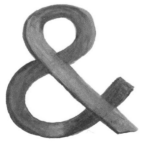 CONTEMPORARY

Trace the ampersands & catchwords, then design some of your own!

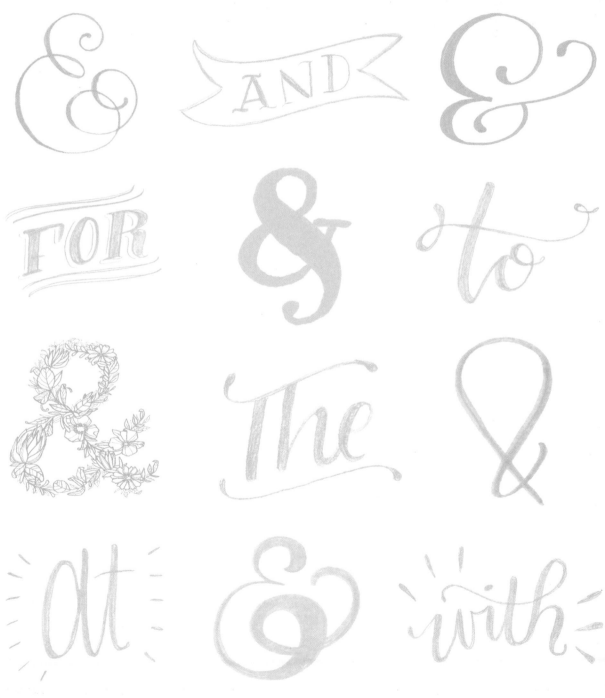

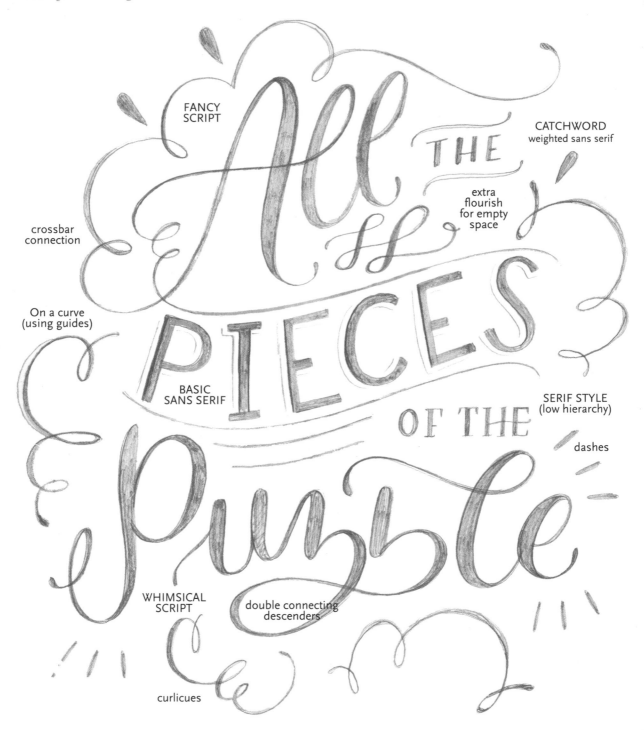

FANCY
SCRIPT

CATCHWORD
weighted sans serif

extra
flourish
for empty
space

crossbar
connection

On a curve
(using guides)

BASIC
SANS SERIF

SERIF STYLE
(low hierarchy)

dashes

WHIMSICAL
SCRIPT

double connecting
descenders

curlicues

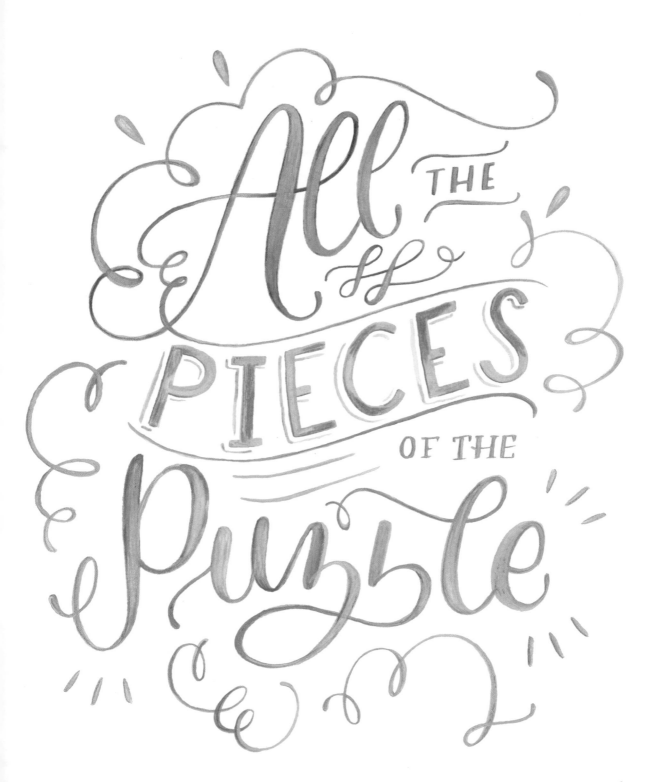

Practice putting all the pieces together here.
Try to come up with some phrases you can use!

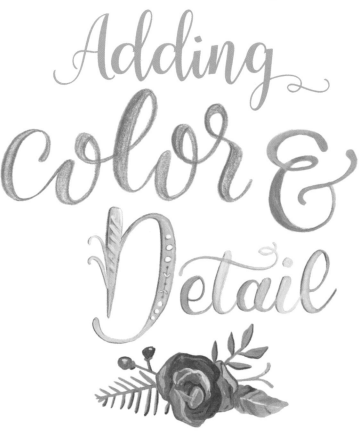

Adding Color & Detail

Now that you've begun drawing letters,
it's time to start dressing them up! You've
experimented with using color on the coloring
pages. Now, I'll show you how to add color to
your own hand-drawn letters, helping you
create vibrant, finished pieces.

In this section we'll explore all that and more,
to make your lettering really dazzle. Have fun
playing with supplies and styles!

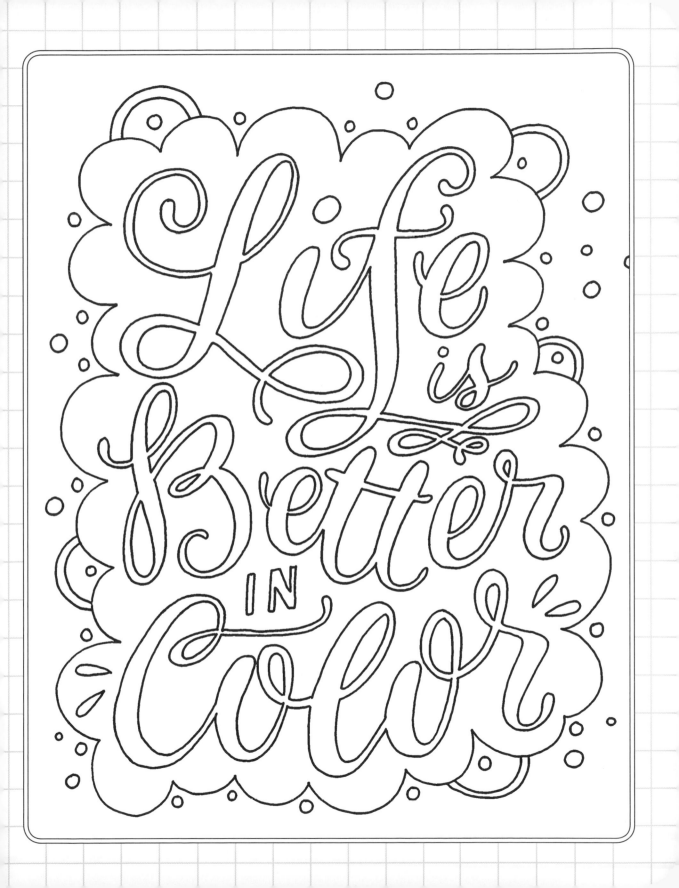

ADDING COLOR WITH

watercolor

Watercolor is a great way to add a touch of color to your lettering. Watercolor paints come in a few different forms: liquid, pan, or tube. If you are new to using watercolors, I recommend starting with a solid pan set because of their portability and affordability.

TO CREATE LETTERING FILLED WITH WASHY, TRANSPARENT HUES:

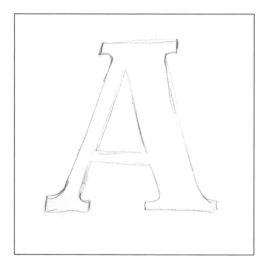

1. Very lightly draw the outline of the letters.

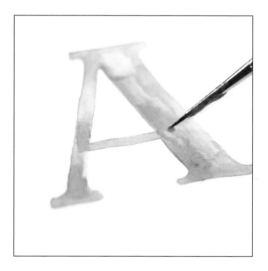

2. Create a watercolor pool of color on your palette by dipping your brush in clean water and then in the pigment, and mixing together. Then, using a small to medium round brush, quickly wash color inside the pencil lines.

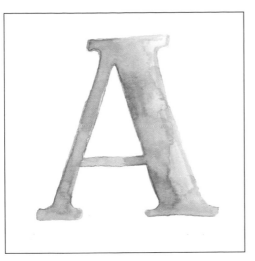

3. Once paint is dry, erase any stray pencil marks.

tips and tricks

- Pencil marks can linger even when drawn as lightly as possible. If you are tired of pesky leftover marks showing, add a lightbox to your wish list. I recommend an Artograph LightPad (see materials section, page 11).

- I prefer nice even surfaces when I do any lettering, so I use either a hot press (smooth surface) watercolor paper or vellum Bristol board. Cold press paper has a more bumpy, textured surface. Try them all and see what you prefer!

- New to watercolor? Practice filling in basic shapes with color before moving on to lettering.

ADDING COLOR WITH

acrylic

For a more opaque look, I recommend painting with acrylic. Acrylic is a water-based paint that dries quickly and is easy to work with. Basic acrylic craft paints will do the trick for beginners, but as you progress I encourage you to try a variety of brands and thicknesses.

You don't need a lot of brushes to get started, and you definitely don't need fancy ones. Choose a few small, round brushes that hold their shape when tested and you'll be set!

TO CREATE LETTERING FILLED WITH BRIGHT, SOLID HUES:

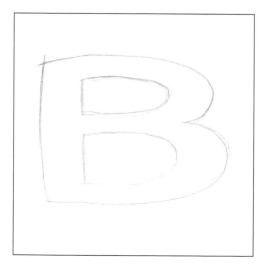

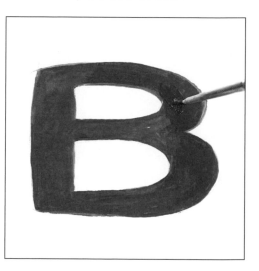

1. Once again, after sketching your letters, lightly draw the outlines in pencil.

2. Mix your acrylic paint with a very small amount of water on your palette. Using a small round brush, apply an even coat of paint to the letter.

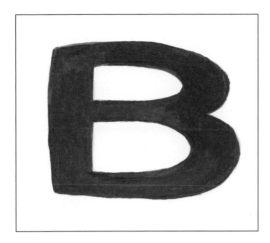

3. If necessary, apply a second coat. Erase any remaining pencil marks once paint is completely dry.

tips and tricks

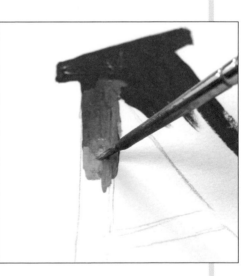

- Try immediately blending into the wet paint with a different color. This wet-into-wet technique is a great way to achieve subtle gradients of color.

- Acrylic paint can be used on almost any surface! If you are tired of paper, try cardboard, wood, or canvas!

ADDING COLOR WITH

colored pencil

Colored pencils are another tool for adding color to lettering, especially for those who aren't comfortable holding a brush. Whether you prefer to use colored pencils as your main source of color, or for little bits of detail, they are a good supply to have in your arsenal.

TO FILL YOUR LETTERS WITH PRECISE, TEXTURED COLOR:

1. Just like we did in painting, very lightly sketch the outline of your letters.

2. With a sharpened colored pencil, color the body of the letter in, using an equal amount of pressure throughout.

3. Increase pressure for darker values and shading.

tips and tricks

Colored pencils work great with other media as well!

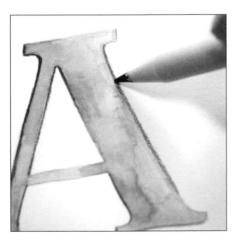

● Add a subtle outline to your watercolor letters once dry.

● Once acrylic or watercolor paints have dried, most colored pencils can be used right on top!

Blending & Shading

Now comes the fun part! Adding contrast and color variations to your lettering will take it to another level! I love blending colors within letterforms, using the three supplies just touched upon.

Let's use a capital L in a script style as an example.

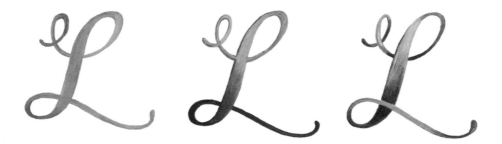

In the second L, I approached blending and shading the colors as if the letter were flat and smooth on top, fading from top to bottom, light to dark, while using a dark colored pencil for accents.

In the third L, I imagined that every overlapping curve passed either behind or in front of the other when they intersected, creating a more three-dimensional look.

I used my colored pencil to shade in the darker areas, pressing more lightly as I faded out.

tips and tricks

- Once you master blending lights and darks, try blending other colors! Here I blended yellows, greens, and blues.

- Let those brush strokes show by taking a more painterly approach!

- A subtle highlight can offer just the right amount of extra glimmer.

Practice your blending and shading inside these words and letterforms!

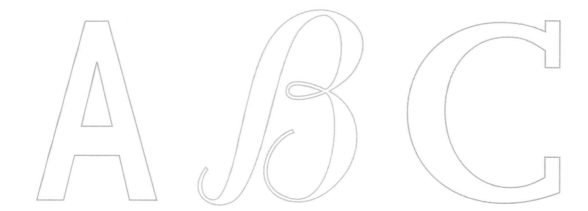

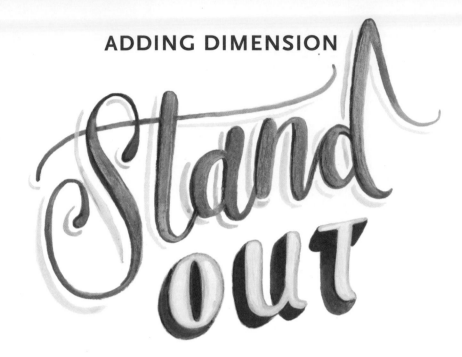

Adding a drop shadow or other indicators of dimension will really make your lettering stand out.

Think of a drop shadow this way: Your letters are floating above your paper, and a soft shadow is cast against the paper. And then think of 3D letters like this: Your letters are sitting on top of your paper, and you are seeing their side walls.

SHADOW

Adding a shadow is easy if you remember to imagine a light source, like a lamp shining down above your letters. For this example, my imaginary light source is above and to the right of my letter, therefore casting a shadow down and to the left of the lettering.

3D

When drawing letters that are three-dimensional, instead of imagining a light source, imagine a viewpoint. Think about it like this: Do you want to look down at the letters or up at them? In the example to the right, I chose to view my letter from above and from the left, meaning I now see the top and left side of my three-dimensional letter.

Try adding a drop shadow in watercolor for a soft, subtle look.

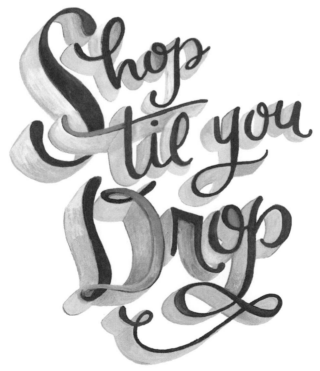

Practice creating drop shadows and dimension with these letters.

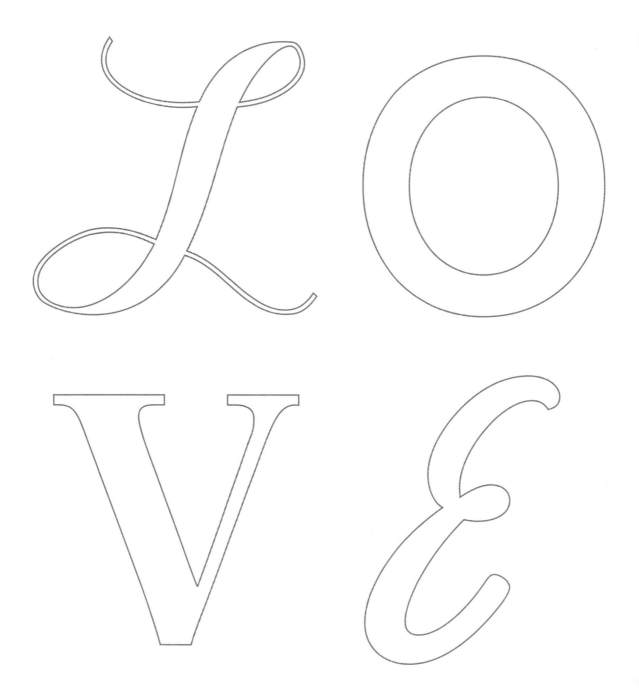

ADDING

illustrations

Now that we've begun adding blended colors, shadowing, and dimension, it's time to introduce some non-lettered elements. I love incorporating small illustrations (florals, leaves, vines, ribbons, banners, etc.) into my lettering work. The tutorials on pages 44-45 show you how to create basic additions; here are some fancier ones in full color!

Approach adding color to these extra elements in the same way you do lettering. Sketch lightly, and then fill with color in the medium of your choice.

Try these mixed media flowers and leaves as a place to start:

FLOWERS

1. Lightly draw the outline of a flower.

2. Wash in watercolor.

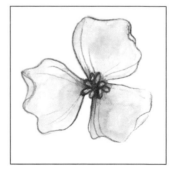

3. Once dry, use colored pencil to add details.

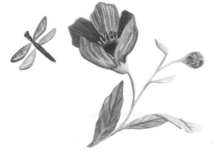

LEAVES

 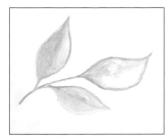

1. Lightly sketch a branch with three leaves.

2. Wash in watercolor.

3. This time, once dry, try adding details with acrylic paint and a small round brush.

Practice creating flower and leaf embellishments here!

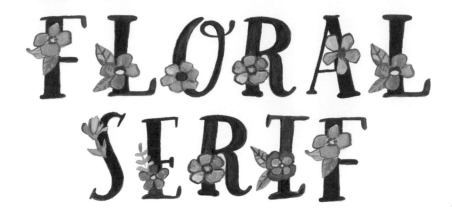

This lettering style brings illustrations and drawing letters together!

EXAMPLE ALPHABET

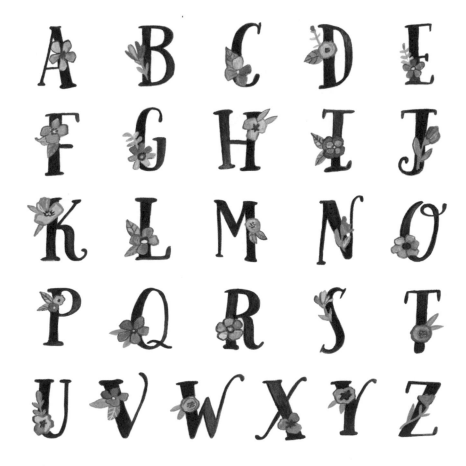

HOW TO DRAW A FLORAL SERIF LETTER:

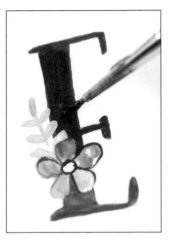

1. Lightly draw a Simple Serif letter (see pages 34-35).

2. Erase the area where you'd like to put the flowers and leaves, and lightly draw those in.

3. Add color! (I used a combination of acrylic paint and colored pencils, but feel free to use whatever medium you feel most comfortable with!)

tips and tricks

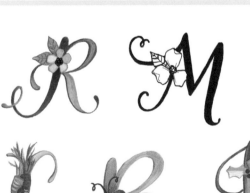

- Try on script letters too!

- Replace the flowers with anything you choose!

Practice drawing Floral Serif letters and creating your own decorative letters here!

EXTRA EMBELLISHMENTS AND

I love adding some extra embellishments and unexpected details to my letters with either colored pencil or acrylic and a small round brush.

Small dots and thin dashes can add an extra punch to your letters!

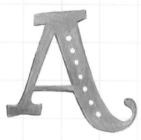

Thin lines, diamonds, laurels, and stars are some of my favorites!

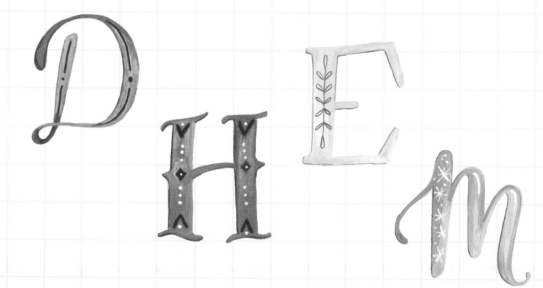

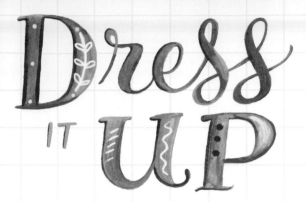

Practice drawing some dressed up and embellished letters!

Combining it All

We've gone over a lot in these three sections, starting with drawing just one letter at a time and progressing to finished, full-color designs.

The finished design on the opposite page puts together all we've learned to the test.

In this piece, I wanted the word "moon" to be at the top of the visual importance totem pole. I filled in the M and N, and painted each letter with acrylic, giving it a textured feel. I used a basic sans serif lettering style to contrast the script lettering in the rest of the phrase.

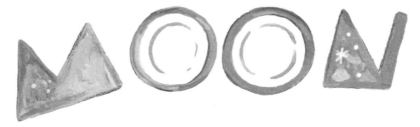

The linking words, "to the" and "and," are low in the hierarchy, so I played them down by making them simpler and smaller. The flowy script lettering moves your eye around and ties the pieces together, along with simple dots and stars.

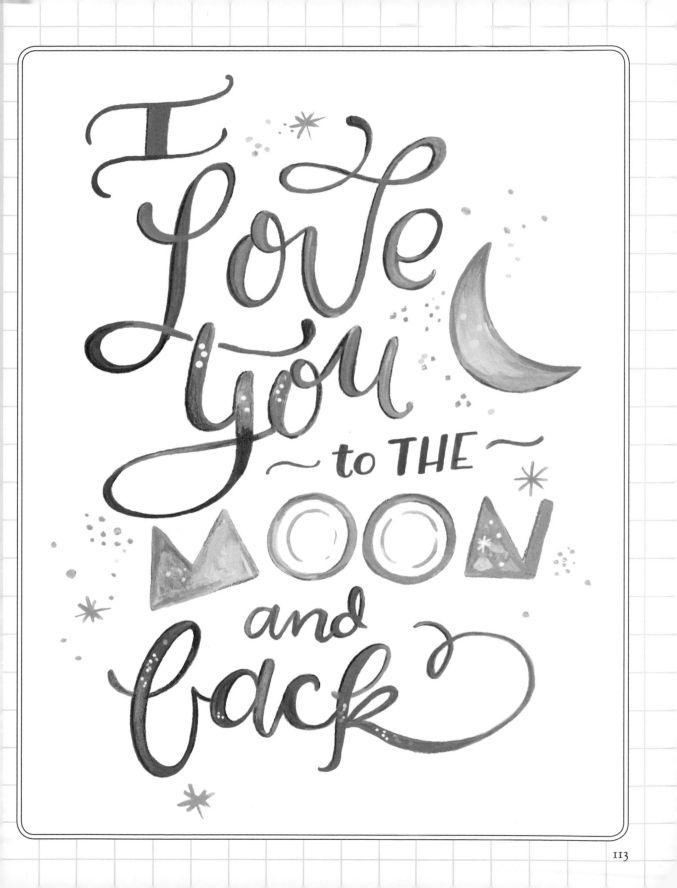

Create a finished hand-lettered phrase that ties together everything you've learned!

Draw a quote that means something to you.

Draw the full name of someone you're fond of.

Draw a lyric from that song you can't get out of your head.

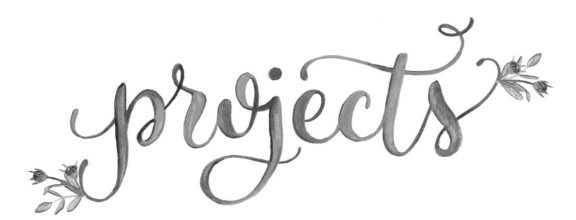

Now that you've learned how to draw letters,
create words, and add color and detail,
it's time to put your new skills to work!

This section will show you ways to add your
own touch of beauty to the world, one pretty,
hand-drawn letter at a time.

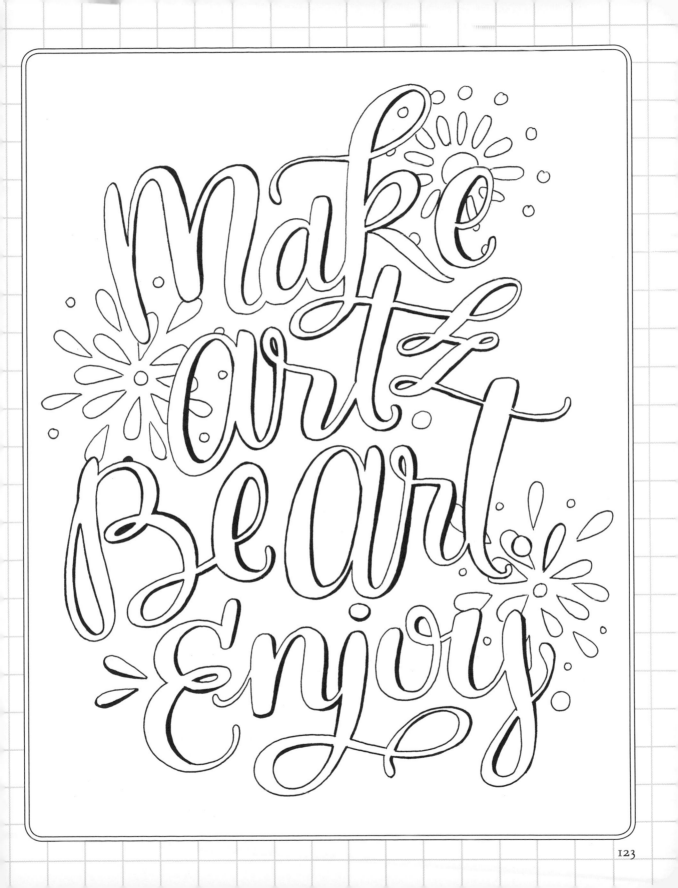

Sending Fancy Snail Mail

One of my favorite simple pleasures in life is opening up the mailbox and finding a hand-addressed letter. Tucked away among the ads, bills, and catalogs, there's a special goodie just for me. Oh, the joy! As I open it, I know that I don't owe the sender money, they aren't trying to sign me up for the latest credit card, and, even if what's inside is a simple "hello," it can be a wonderful moment in my day.

For this first project, I challenge you to take what you've learned so far in this book, and put it into practice in a very tangible way. Send some snail mail!

Addressing an envelope is the perfect way to practice your lettering skills. Each name and address is simply a combination of letters, words, and phrases. The only rules are that it must fit a stamp and be legible! (I sometimes do the "husband test," and if he can read it easily, I trust the post office can, too!)

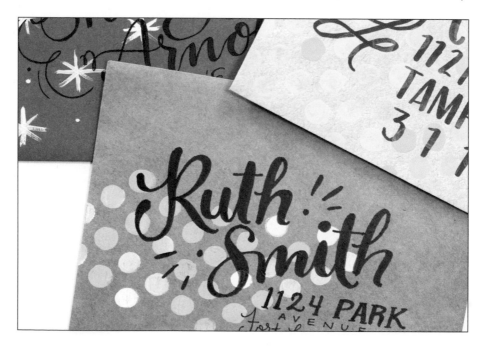

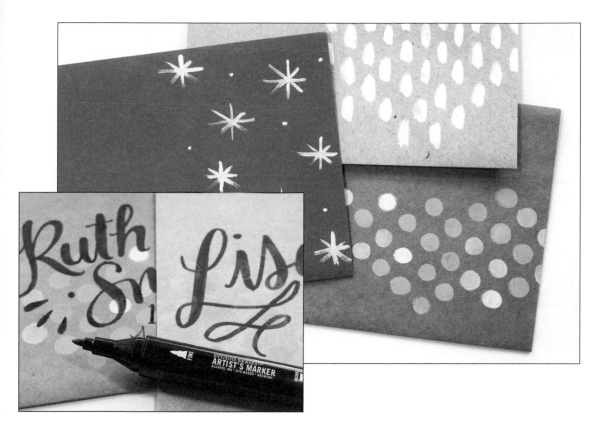

PATTERNED ENVELOPES

If you aren't super confident in your lettering skills yet, painting your envelope first is an easy way to dress it up. Painting simple patterns on your envelope before adding your lettering is quick, but makes a big impression.

Polka dots, dashes, and stars are a great place to start. It's simple: Just paint your patterns in acrylic (be sure not to use too much water), let dry, and draw the address on top using any type of pen. (I like to use an alcohol-based ink marker.) Voilà! Fancy mail!

tips and tricks

If you don't trust your drawing skills enough to skip right to a pen, lightly sketch your lettering on the envelope using a pencil first!

WHITE INK

I absolutely love the look of white ink on a bold, colorful envelope.

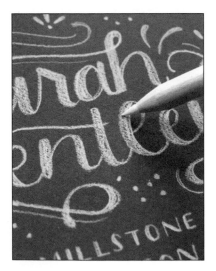
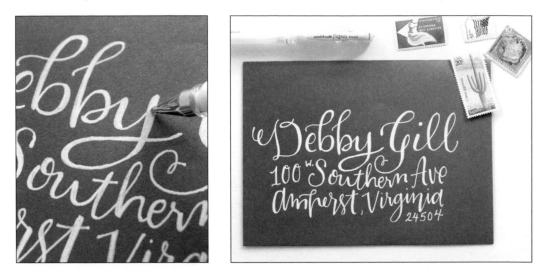

Or for an even softer effect, try using a colored pencil. On this navy blue envelope, I drew my letters with a white colored pencil. On the dark paper, it really pops—and almost gives it a chalkboard effect. Little doodles and embellishments add a finishing touch.

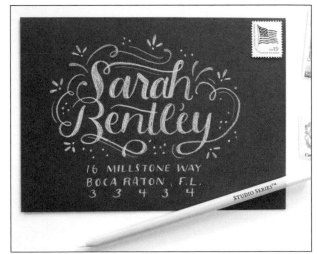

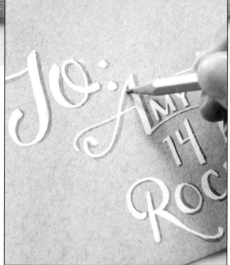

For an even punchier look, I'll add a drop shadow using a graphite pencil.

(My go-to pen for white ink is a Uni-ball Signo Gel Pen. The white ink is very opaque and it writes super smooth!)

PAINT IT!

If you have the time to make something extra special, try painting the name and address! I love painting on kraft envelopes—the colors pop so nicely against the neutral brown.

When painting an envelope, I sketch the letters very lightly in pencil first, paint on top using acrylic, and then use a colored pencil to add a quick drop shadow.

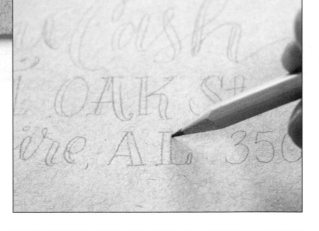

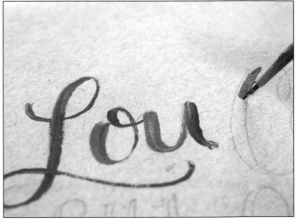

ADD ILLUSTRATIONS

A banner is a simple way to add some non-lettered artwork to an envelope.

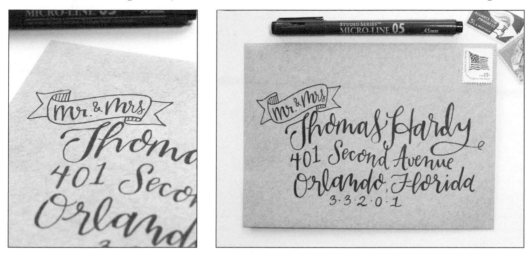

Or fill up your envelope with flourishes and embellishments!

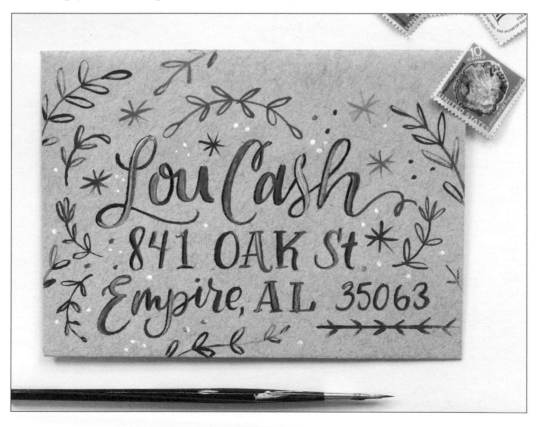

Lettering on Gift Tags

Making your own gift tags is easy, and cheaper than buying them! All you need is some thick paper, a pen, and a hole punch to create your own hand-lettered tags.

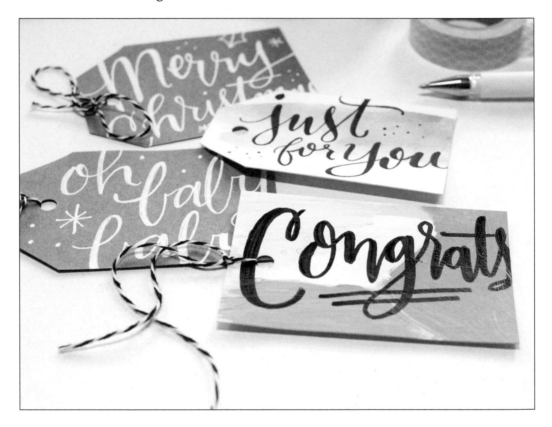

TO CREATE A HAND-LETTERED GIFT TAG:

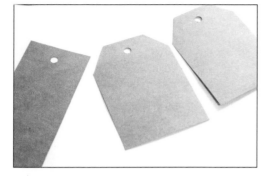

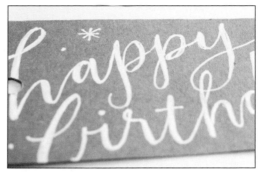

1. Cut cardstock paper into the size and shape you'd like your tags to be, then punch a hole. I chose a sturdy kraft paper.

2. Using a white gel pen, draw your word or phrase, perfect your lettering, and add some simple embellishments.

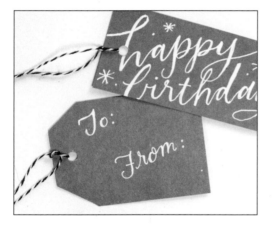

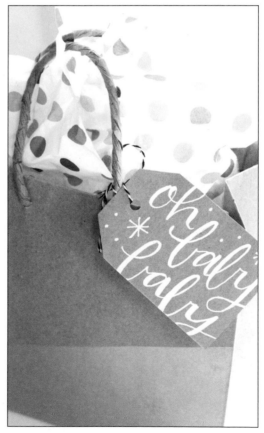

3. Add "to:" and "from:" on the back, and attach to your gift.

Of course, in my world, the more art supplies, the merrier!

ADD A SPLASH OF WATERCOLOR TO YOUR TAGS FOR A POP OF COLOR.

1. Paint diluted color across pre-cut tags. For these, I used a canvas paper specifically made to hold paint. But watercolor paper and Bristol board can be great options as well.

2. Let dry, and add lettering with a black micro-line pen.

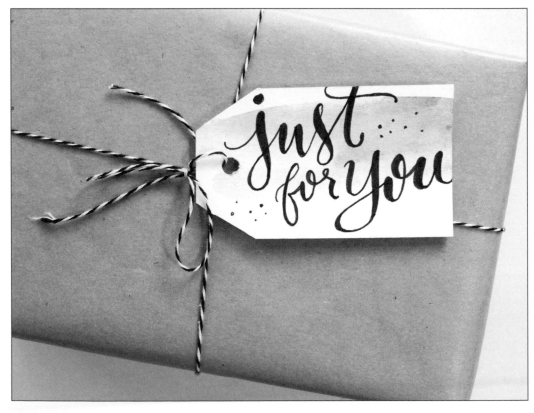

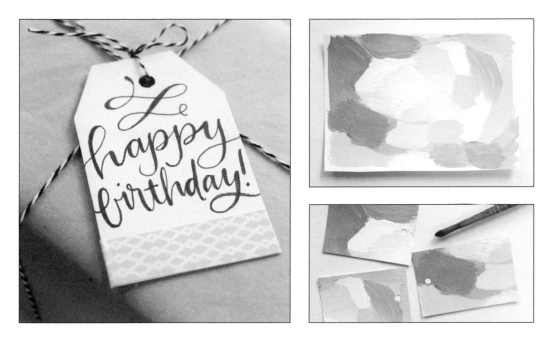

There are so many simple ways to mix it up and compliment your lettering skills. Add washi tape for an instant colorful pattern or cut tags out of pre-painted paper to create an abstract collection of tags.

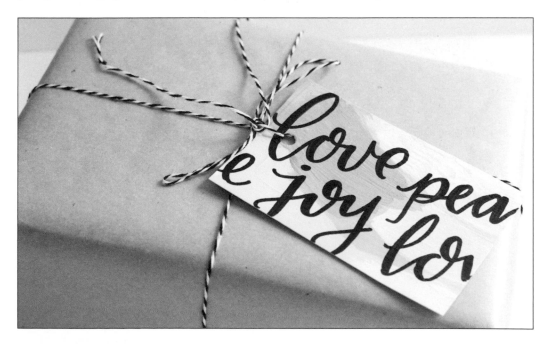

Lettering on Gift Wrap

 love creating my own gift wrap! It's a great way to personalize gift giving and another place to showcase your lettering skills!

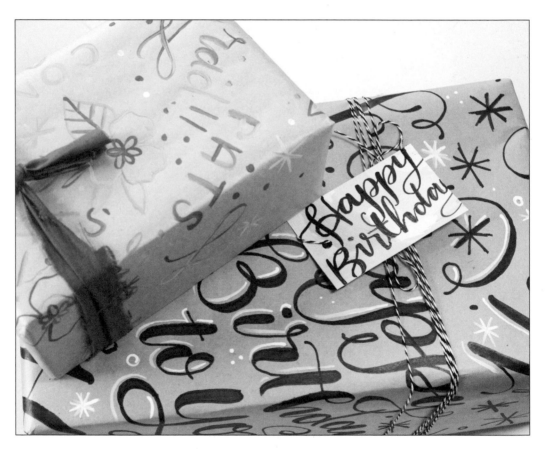

TO CREATE HAND-LETTERED WRAPPING PAPER:

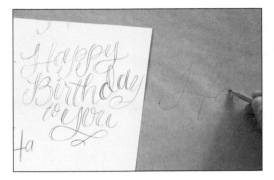 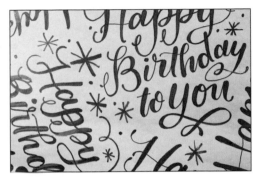

1. Lay out blank wrapping paper on a flat surface and sketch words lightly. (For the example, I'll be doing *Happy Birthday to You*, using a sketch I created back in the Crafting Phrases lesson on page 60.)

2. Rotate your paper and repeat your phrase all over your paper, before using a black marker to draw on top. Use simple embellishments, such as stars and dots, to fill in the gaps.

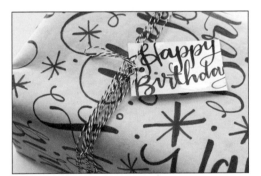

3. Wrap and add your gift tag!

Use white paint for extra pop, or make the occasion even more festive with bright colors!

Hand-Lettered Wooden Blocks

I'm constantly changing the décor around my house, so this is a fun way to add a pop of color and easily switch out a word or phrase. Make a set for a special gift or create a unique work of art for your home.

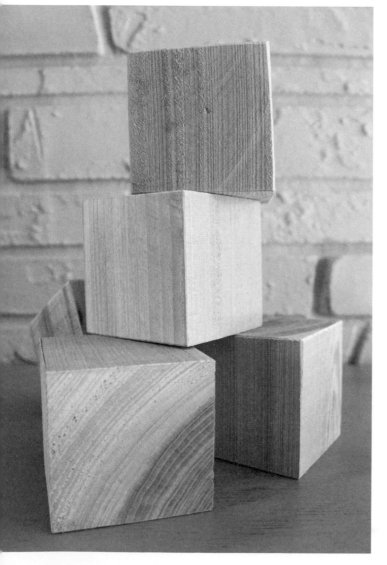

WHAT YOU'LL NEED:

- 3" wooden blocks, sanded (I cut my own from cypress. However, for those without tools, you can buy wooden blocks online and at most craft stores.)

- Acrylic paint (various colors)

- Brushes (various sizes)

- Pencil

- Sandpaper

TO CREATE HAND-LETTERED WOODEN BLOCKS:

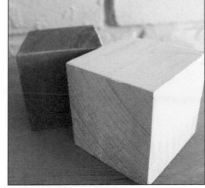

1. Use an acrylic-based paint to block in colors on all sides. (I like to jump in with color right away, but if you aren't a step-skipper like me, go ahead and slap a primer on there first).

2. Next, lightly draw letters on every side using a pencil. Keep in mind that each block will have 6 letters. Mix them up however you like, just make sure you have plenty of vowels! I had a few words in mind that I wanted to make sure I could spell out when finished, so I planned accordingly.

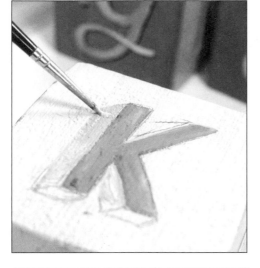

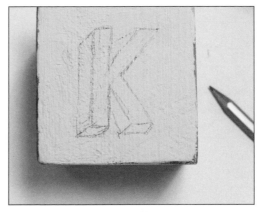

3. Then, paint your letters using acrylic paint! (Most of my letters have drop shadows or dimension, so I used lots of contrasting colors.) Work by blocking in color first, then adding detail.

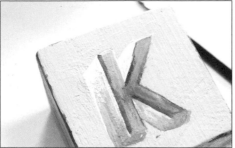

4. Make them as detailed or simple as you'd like!

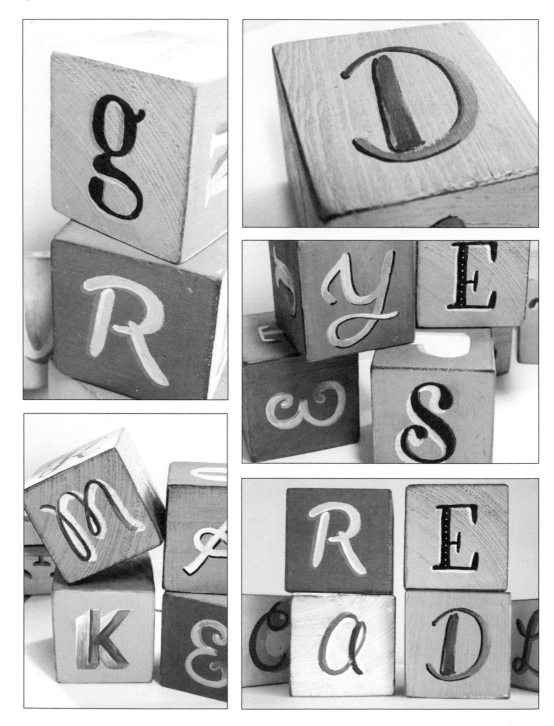

tips and tricks

- Imperfections add character, so don't stress over tiny "mistakes."

- To give my letter blocks an aged look, I sanded the edges once the paint was dry, and rubbed on a wood stain.

Directional Signs

Wooden signage is an awesome way to add character to your backyard or home. I created a directional sign for my yard using found wood and paint. It was cheap, easy, and fun!

FIND SOME WOOD

Simple enough, right? Just look around your neighborhood for old fence boards. I enjoy scavenging for free stuff, plus the aged wood gives the signs great character that it would take years for a new piece to acquire. Old pallets are easy to find as well. Just keep your eyes open and start collecting! And be careful around any rusty nails or screws. Scavenge wisely, folks! (Or, of course, go ahead and buy some new wood if you're so inclined.)

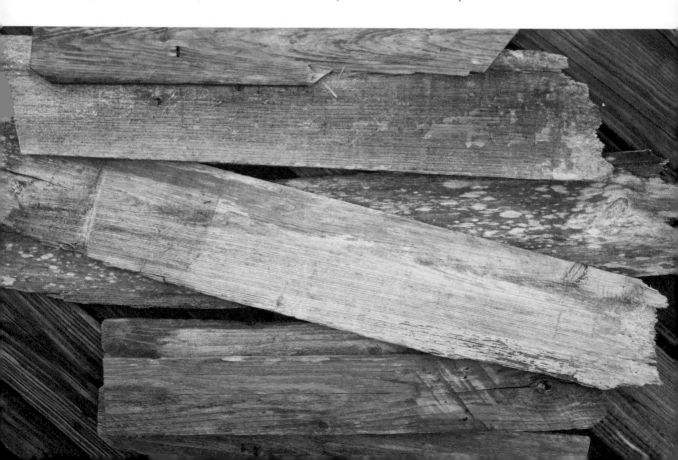

PREP IT

The next step is to prepare the wood for lettering.

First, sand down any rough spots and carefully remove any remaining nails.

Next, you can use basic acrylic-based outdoor latex paint (or any acrylic will do), and loosely slap on some color.

I chose tropical blues and greens for some of the signs. Others, I left plain.

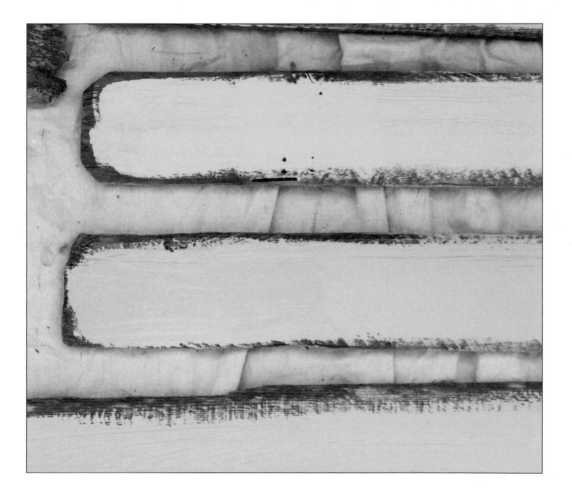

SKETCH

While the boards are drying, do some sketches of the lettering you plan to draw. I mingled script lettering with print, and tried to create a variety of styles, mixing it up for each location.

Once you are happy with your sketches, reference them and lightly sketch each word on the wood. Depending on the color paint you use, it may be tricky to see your sketches. I recommend trying a variety of pencils to see what will work for you.

BLOCK IN THE LETTERS

Next, start painting the letters. I like to get all the simple color blocking done first, and then go back for the details (shading, drop shadows, etc.).

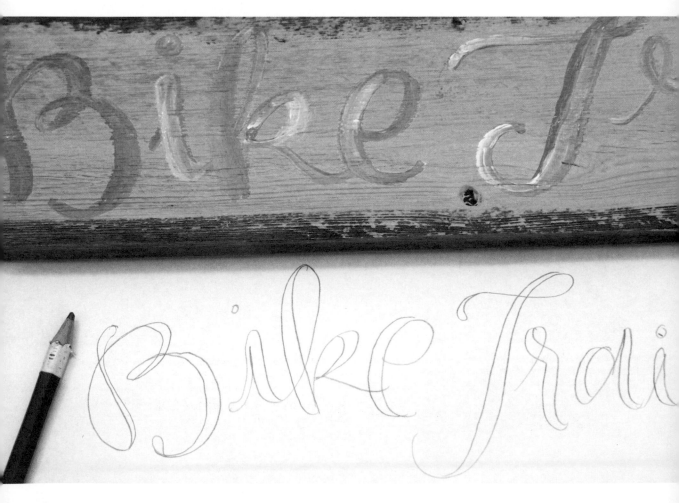

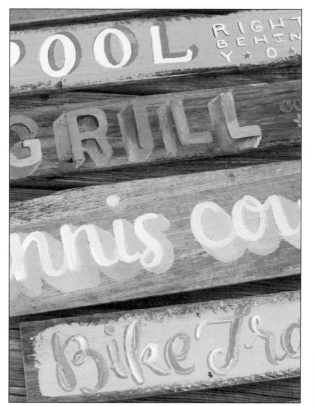

ADD DETAIL

Adding detail is always my favorite part! A bold drop shadow can add so much to your signs, and choosing contrasting colors and shades will make your lettering really stand out.

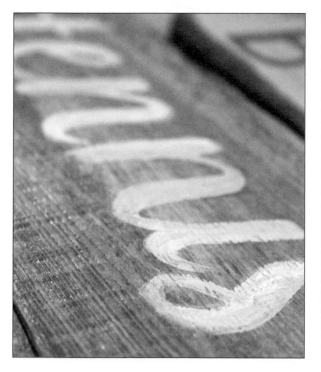

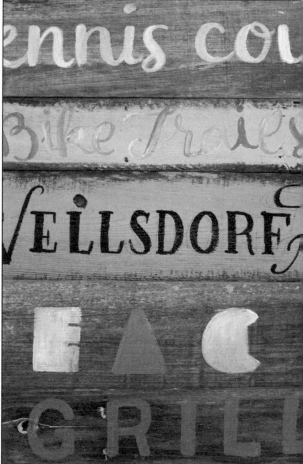

But once again, I'm more concerned with character than perfection. The "mistakes" are just quirky reminders of the hand-drawn nature of the art.

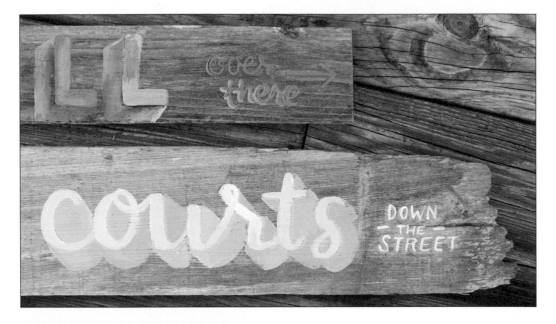

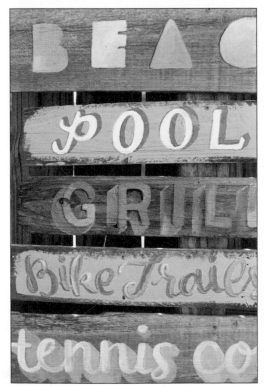

SEAL IT

Once your pieces are completely dry, give them a protective seal. Any time wood is left outside and exposed to the elements, it's going to get weathered. You can slow down this process considerably if you use a clear protective sealant. (The most durable I've found is Helmsman Spar Urethane.)

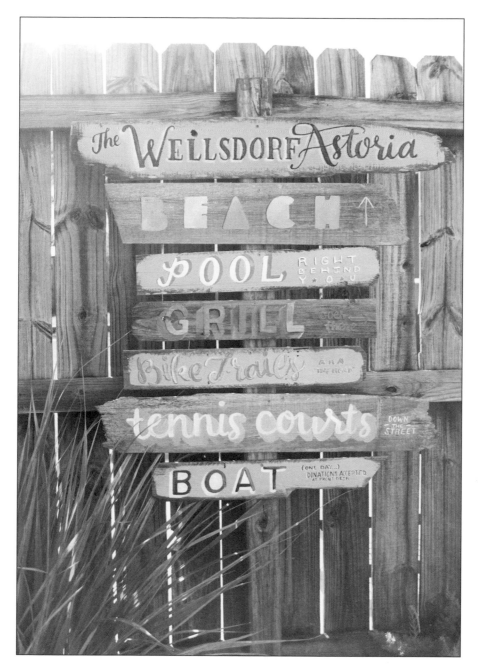

INSTALL IT

Lastly, install your new decor!

I pre-drilled holes in each sign before screwing them into the fence. Now, if we move, or the fence is replaced, it's easy to take them down and move them.

Large-Scale Lettering

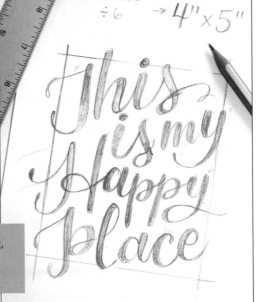

Make a big statement with a large hand-lettered art piece. With this project, I'll show you how to take a small sketch and turn it into a large painting. Using the gridding method described below, you can be sure to keep your proportions correct when enlarging any smaller drawing or photo.

TO HAND-LETTER A LARGE PIECE:

WHAT YOU'LL NEED:

- Pencil

- Eraser

- Ruler

- Large canvas or wood panel (For this project I used a 24" x 30" birch panel. I prefer wood to canvas because of the smoother surface.)

- Acrylic paints

- Brushes

1. Prime the wood panel. I used an acrylic-based interior paint and gave the wood a good two coats.

2. While the panel or canvas is drying, do some sketches of the lettering you plan to paint.

It's important that your sketches are in proportion to your final canvas/board. Because my final board was 24" x 30", I drew my sketch in a 4" x 5" box. I got those dimensions by using the common denominator of 6. In other words, both 24 and 30 are divisible by 6. 24 divided by 6 is 4, and 30 divided by 6 is 5. Now I can be sure my sketches are correctly proportioned. The final piece will be exactly 6 times the size of the sketch.

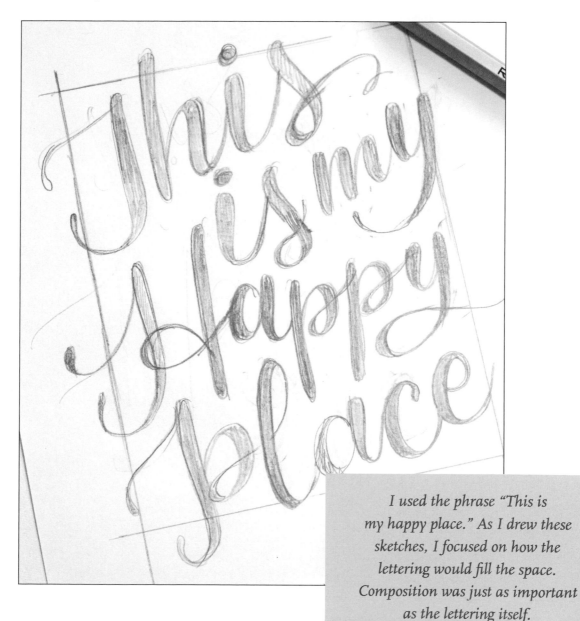

I used the phrase "This is my happy place." As I drew these sketches, I focused on how the lettering would fill the space. Composition was just as important as the lettering itself.

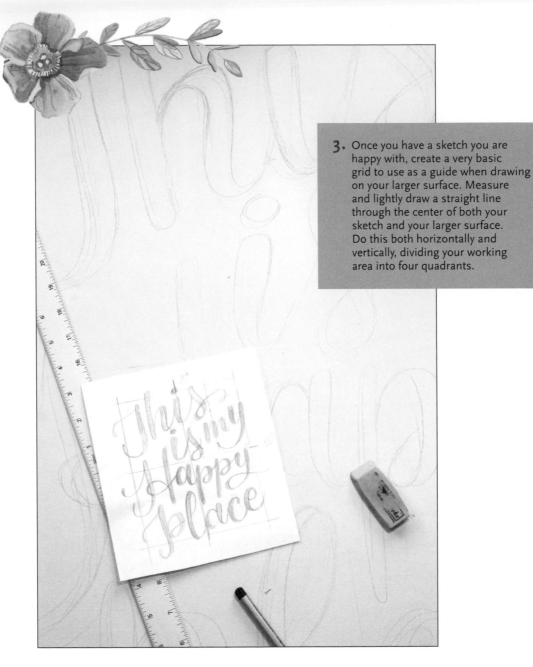

3. Once you have a sketch you are happy with, create a very basic grid to use as a guide when drawing on your larger surface. Measure and lightly draw a straight line through the center of both your sketch and your larger surface. Do this both horizontally and vertically, dividing your working area into four quadrants.

This simple gridding method is my go-to way of enlarging smaller sketches. It creates a very basic (yet extremely helpful) guide as you transfer your small drawing to the larger surface. Breaking up an image into four smaller images makes it easier to copy, and if the placement of something seems off, you'll be able to see where it should be more clearly.

If you're working with either a very large surface or a very complex composition, it may help to break up your drawing into more than four boxes.

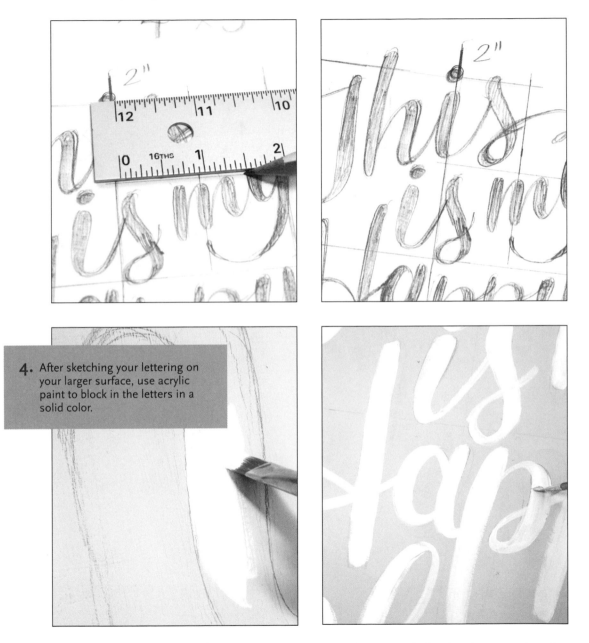

4. After sketching your lettering on your larger surface, use acrylic paint to block in the letters in a solid color.

For my piece, I wanted the lettering to be white, and the background to be varying shades of blues and greens.

5. Next, block in areas of the negative space (background) with your choice of colors. I prefer to work expressively and quickly, as you can see!

6. Once you've blocked in all of the background color, revisit your lettering by tidying it up with another coat of paint. Then, using a contrasting color, add a bit of dimension to the bottom left of the lettering.

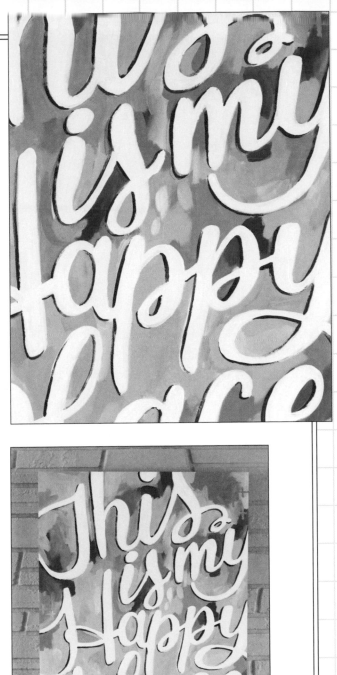

I love adding textures and patterns to my work, so I added gestural marks with a pencil, expressive dashes and dots, and other subtle pieces to my background.

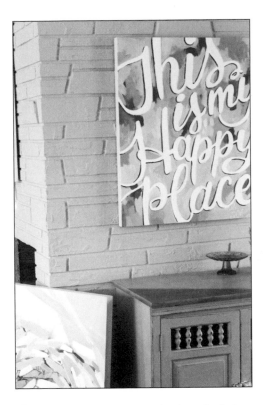

7. Hang your new art, step back, and admire your work!

Lettering in Your Art Journal or Sketchbook

An art journal or sketchbook is a great place to incorporate your hand-lettering and experiment with different supplies and techniques.

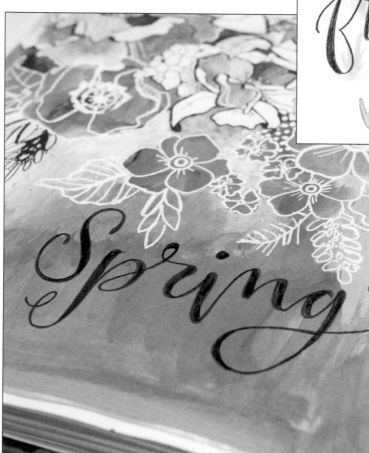

Add simple titles or themes for your pages.

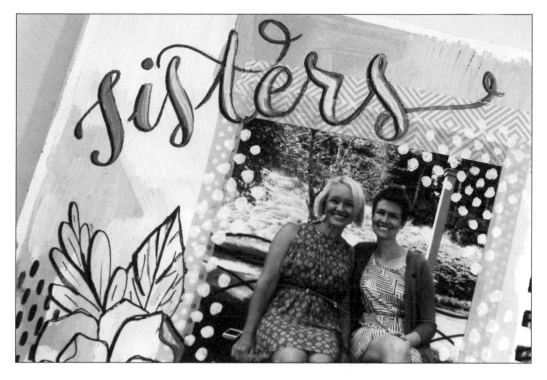

I love adding just one word to a page when I've used a photo. It's simple to come up with something (a name, a place, etc.), and it personalizes the page.

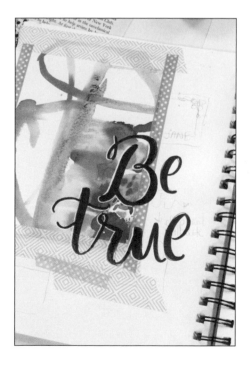

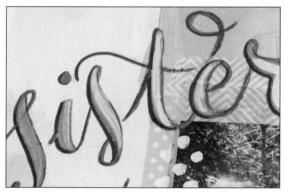

Experiment with layering and using different materials on top of the paint, photos, and tape.

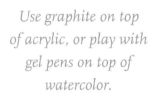

to know how to PLAY

Use graphite on top
of acrylic, or play with
gel pens on top of
watercolor.

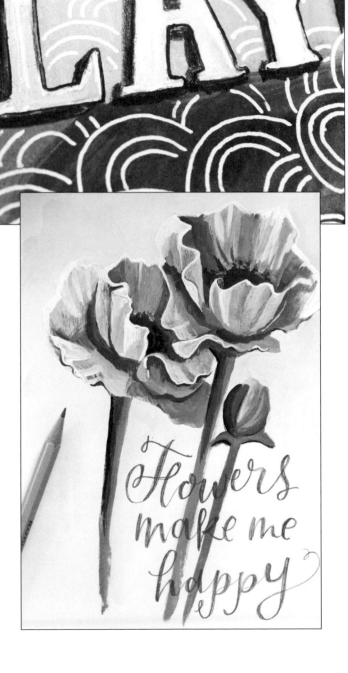

Flowers
make me
happy

154

tips and tricks

Allow yourself to embrace imperfection by focusing more on your creative ideas than technical execution.

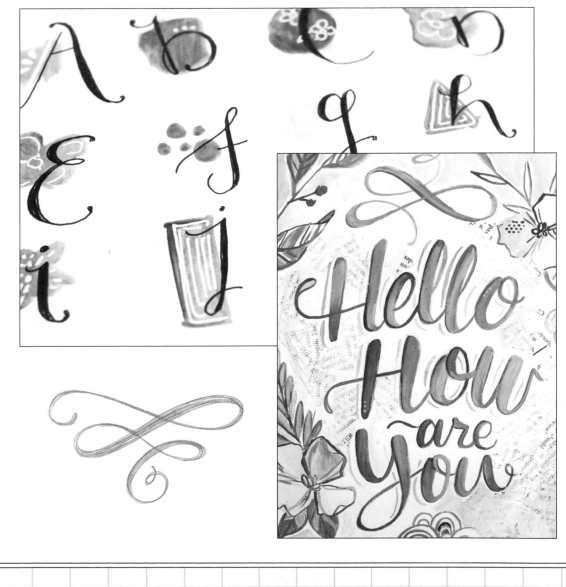

Lettering Everywhere!

You can add a special, personalized touch to just about anything with hand-lettering. Here are a few more ways to inspire you to add your own unique hand-drawn lettering to the world around you.

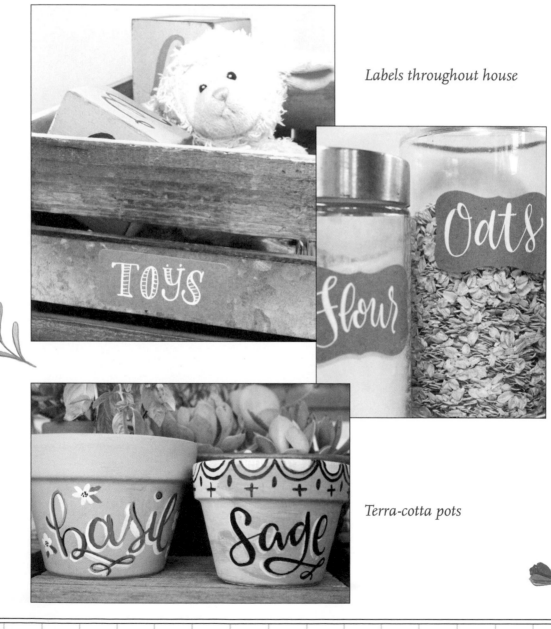

Labels throughout house

Terra-cotta pots

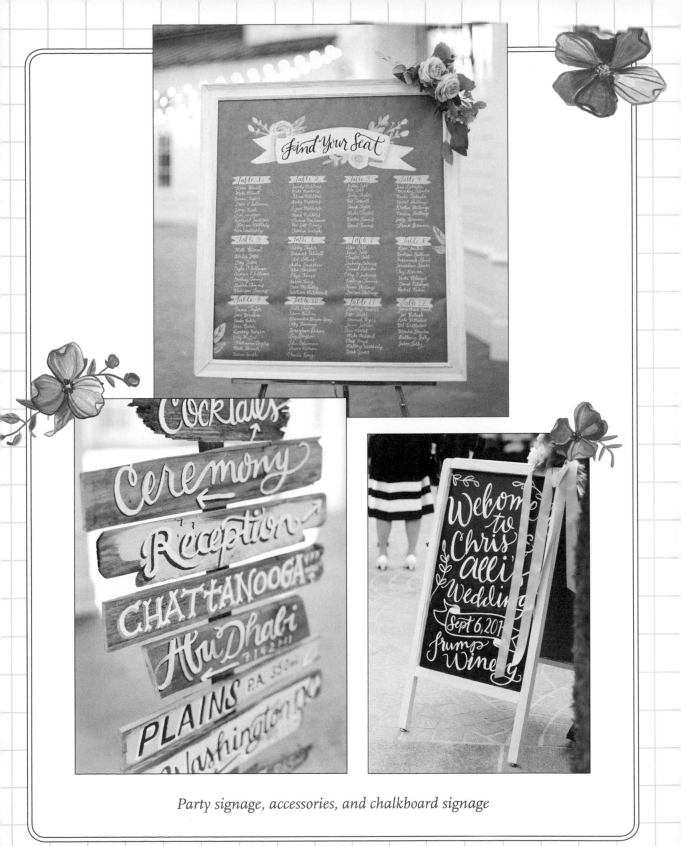

Party signage, accessories, and chalkboard signage

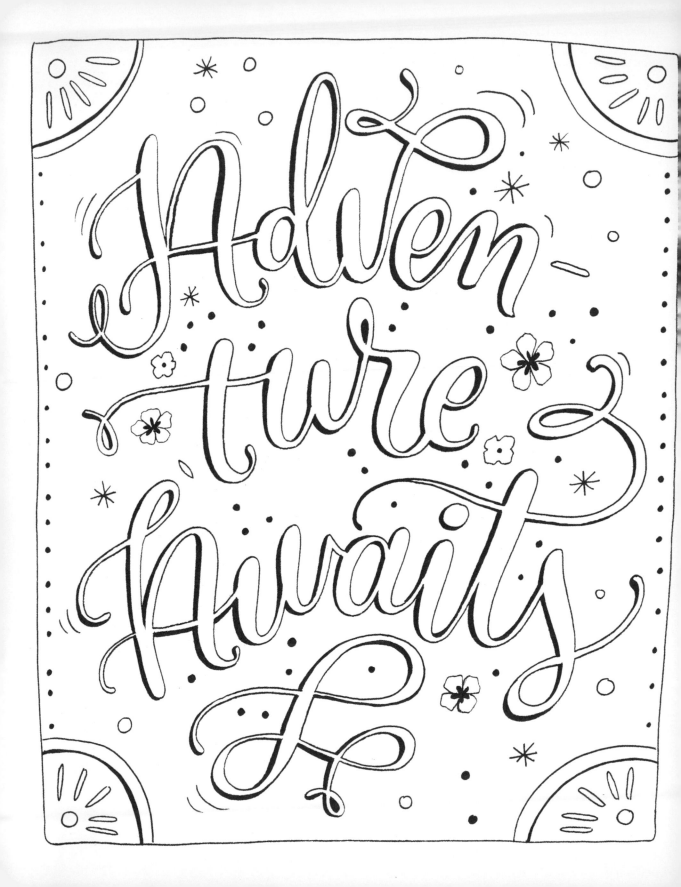

Acknowledgments

I'd like to thank the following people:

My husband, Brent, whose support has never wavered
from that first day I attempted to hand-address an envelope
almost four years ago. Thank you for emptying my trash can
every afternoon, keeping the grass outside my studio window
green and manicured, and making the coffee every day.
You are my best friend, plain and simple.

Our foster son, Baby Bear, who came into our lives at the
very start of this book. Thank you for the joy you bring to
our days, and for sleeping through the nights. You have
turned our world upside down in the most marvelous way!

Heather, Barbara, Talia, and the rest of the Peter Pauper Press team.
Thank you for the opportunity to work with such a talented team
and for all the encouraging guidance as this book came together.

Alisa Burke, my friend and mentor.
Your support has meant the world to me!

My friends and family, who love and support
me in spite of my artistic mood swings.

And most of all, God; without You,
I am nothing.

About the Author

South Florida artist Megan Wells is inspired by beautiful words and God's natural wonders. Her work combines whimsical florals with flowing letterforms. When not busy creating in her studio, you can find her riding bikes to the beach with her husband Brent, their two foster sons, and lovable min-pin George.

See more of Megan's work at makewells.com or follow along on social media @makewells.